D0604519

HOW TO DRAW CARTOONS...

How To Draw Cartoons...
by ·MADDOCKS·

A book for the budding Cartoonist by a Cartoonist

MICHAEL O'MARA BOOKS LIMITED.

FIRST PUBLISHED IN 1991 BY MICHAEL O'MARA BOOKS LIMITED.
9. LION YARD, TREMADOC ROAD LONDON SW4 7NQ

How To Draw Cartoons COPYRIGHT © 1991 by PETER MADDOCKS

A CIP CATALOGUE RECORD FOR THIS BOOK IS AVAILABLE
FROM THE BRITISH LIBRARY.

ISBN 1—85479—078—1

PRINTED AND BOUND IN PORTUGAL
BY PRINTER PORTUGUESA.

CONTENTS

OVER THE PAGE!

What shall I draw with? Pen, Pencil or brush?

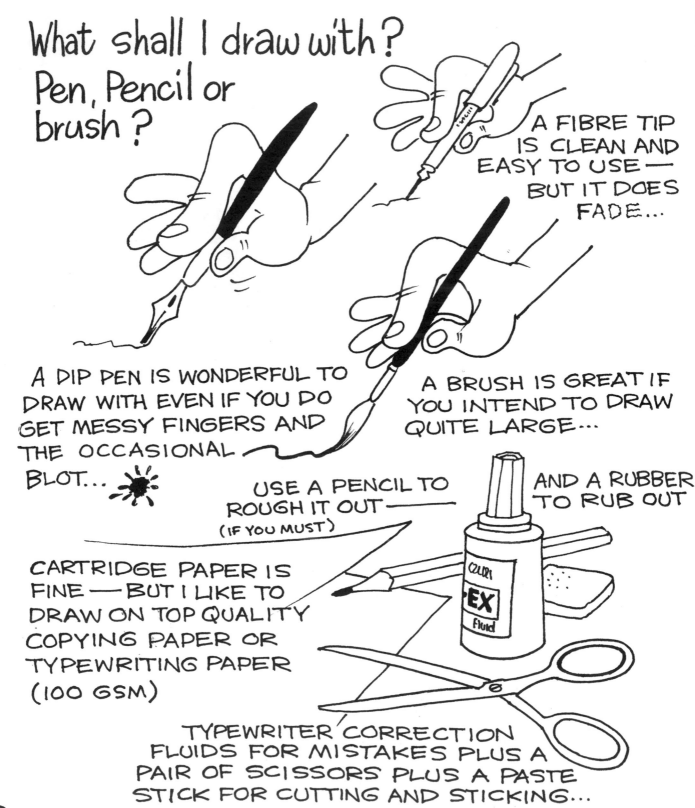

A FIBRE TIP IS CLEAN AND EASY TO USE — BUT IT DOES FADE...

A DIP PEN IS WONDERFUL TO DRAW WITH EVEN IF YOU DO GET MESSY FINGERS AND THE OCCASIONAL BLOT...

A BRUSH IS GREAT IF YOU INTEND TO DRAW QUITE LARGE...

USE A PENCIL TO ROUGH IT OUT — (IF YOU MUST)

AND A RUBBER TO RUB OUT

CARTRIDGE PAPER IS FINE — BUT I LIKE TO DRAW ON TOP QUALITY COPYING PAPER OR TYPEWRITING PAPER (100 GSM)

TYPEWRITER CORRECTION FLUIDS FOR MISTAKES PLUS A PAIR OF SCISSORS PLUS A PASTE STICK FOR CUTTING AND STICKING...

WHAT SIZE DO I DRAW?

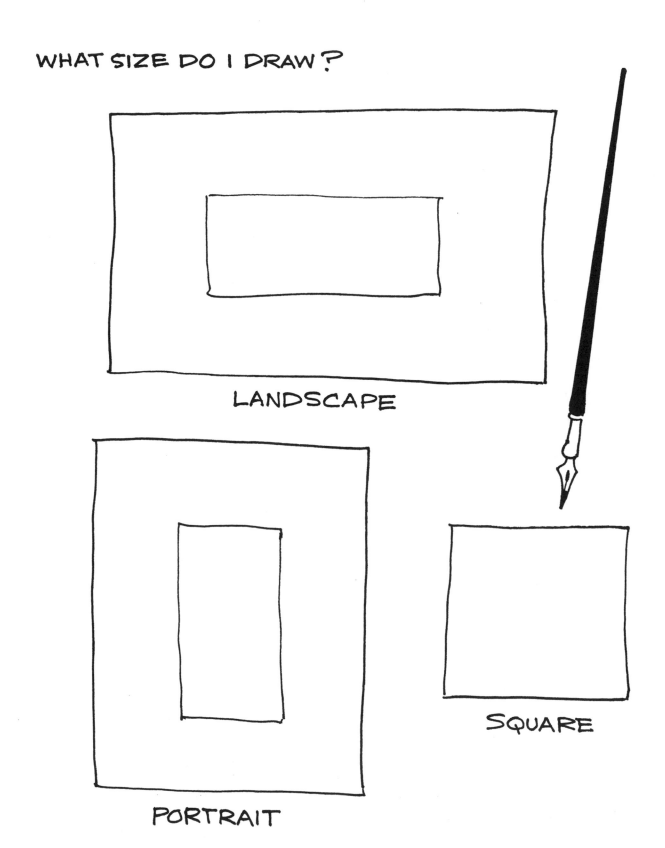

LANDSCAPE

PORTRAIT

SQUARE

UNLESS YOU CAN'T HELP YOURSELF — TRY NOT TO
DRAW TOO LARGE, ARTWORK MOUNTS UP OVER THE
YEARS AND YOU'LL HAVE TO MOVE HOUSE EVERY
DECADE —

MOST OF THE ARTWORK IN THIS BOOK IS SAME
SIZE SO YOU CAN SEE I DRAW QUITE SMALL.

TRY TO THINK OF SHAPE BEFORE YOU START,
IS IT LANDSCAPE OR PORTRAIT ? BECAUSE
IF IT'S GOING TO BE REPRODUCED IN A
MAGAZINE OR NEWSPAPER, SHAPE IS VERY
IMPORTANT...

A GOOD WORKING SHAPE IS A SQUARE
BECAUSE IT WILL BLOW UP OR
REDUCE EASILY

IF YOU JUST DRAW WILLY NILLY
ANY OLD SHAPE YOU WILL
FEEL THE CUTTING EDGE OF
THE LAYOUT ARTIST'S
SCISSORS — AND YOU CAN GUARANTEE
HE'LL CHOP OFF THE IMPORTANT BIT —
SO BE
WARNED!

CUT...

STICK

✰ TRY DRAWING IN A SQUARE SHAPE...

RAMBRANDT

STYLE IS UP TO YOU—BUT YOU MAKE UP A
FACE WITH EYES, NOSE AND A MOUTH——

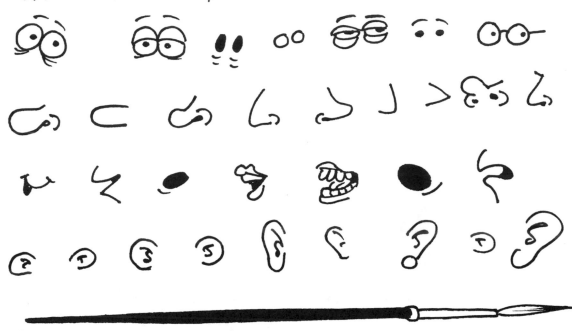

SO TAKE YOUR PICK AND MAKE A FACE —
WHEN YOU THINK OF THE MILLIONS OF HUMAN
FACES MADE UP WITH SUCH A SIMPLE SET
OF COMPONENTS IT'S A WONDER WE DON'T
ALL LOOK ALIKE ——OR PERHAPS WE DO?

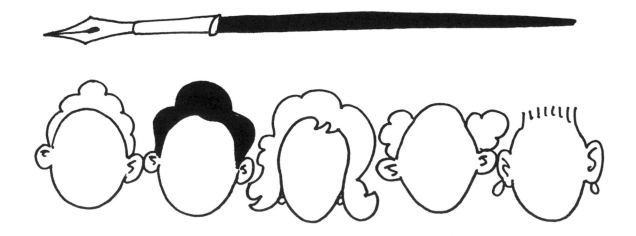

Make a Cartoon face...

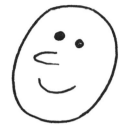
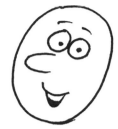
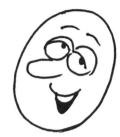
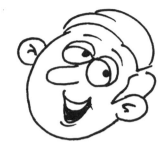

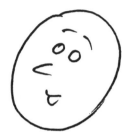
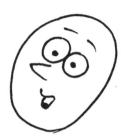
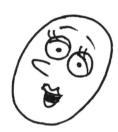
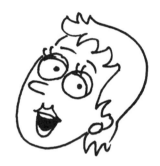

THEN TURN IT AROUND...

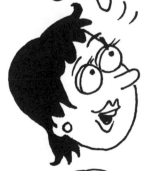
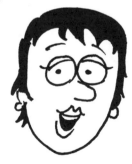

AND HAVE A GO
AT IT FRONT ON
(THIS IS THE
DIFFICULT BIT)

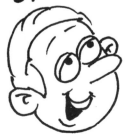
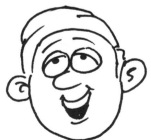

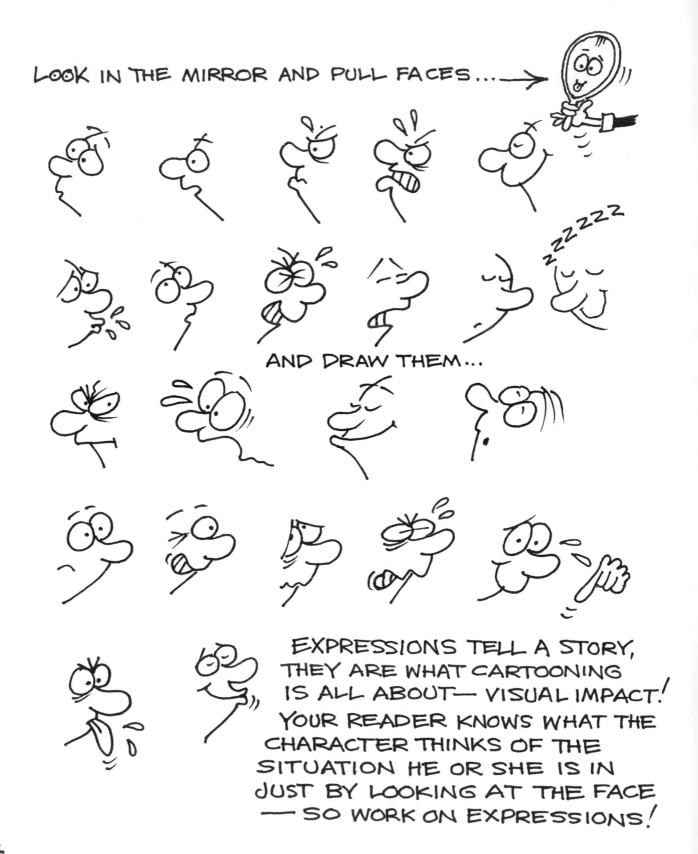

LOOK IN THE MIRROR AND PULL FACES...→

AND DRAW THEM...

EXPRESSIONS TELL A STORY, THEY ARE WHAT CARTOONING IS ALL ABOUT— VISUAL IMPACT! YOUR READER KNOWS WHAT THE CHARACTER THINKS OF THE SITUATION HE OR SHE IS IN JUST BY LOOKING AT THE FACE — SO WORK ON EXPRESSIONS!

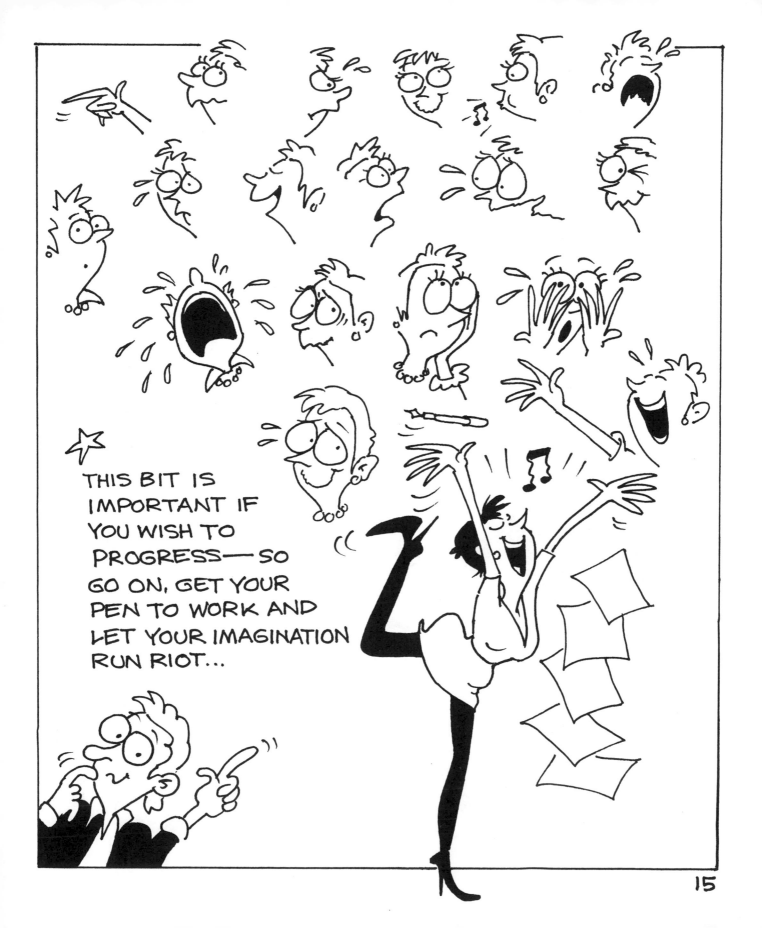

THIS BIT IS
IMPORTANT IF
YOU WISH TO
PROGRESS—SO
GO ON, GET YOUR
PEN TO WORK AND
LET YOUR IMAGINATION
RUN RIOT...

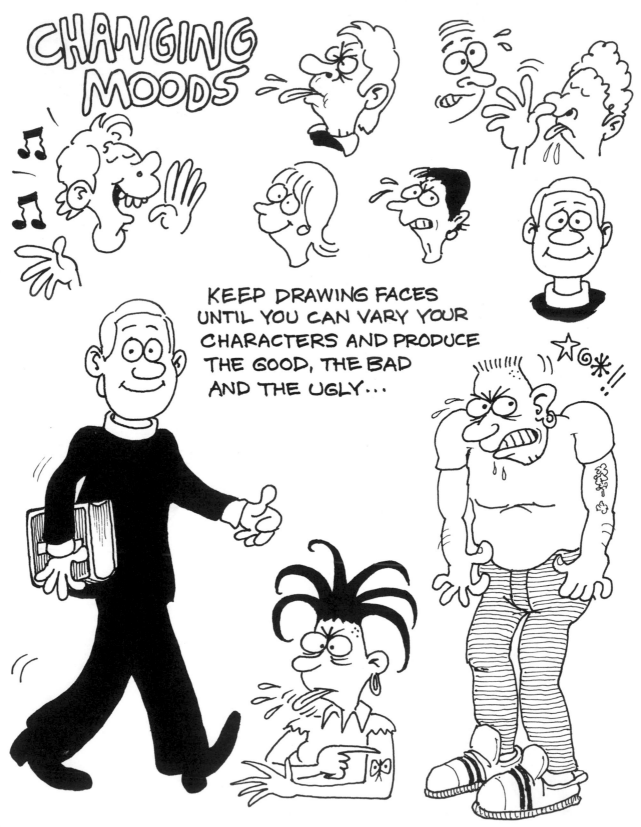

CHANGING MOODS

KEEP DRAWING FACES
UNTIL YOU CAN VARY YOUR
CHARACTERS AND PRODUCE
THE GOOD, THE BAD
AND THE UGLY...

CHANGING Faces

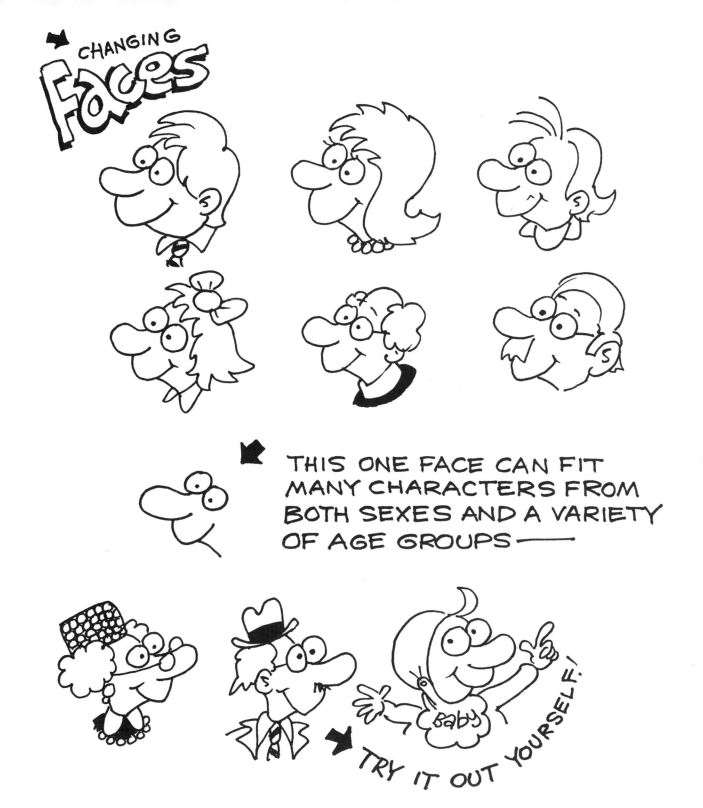

THIS ONE FACE CAN FIT MANY CHARACTERS FROM BOTH SEXES AND A VARIETY OF AGE GROUPS——

TRY IT OUT YOURSELF!

FACIAL EXPRESSIONS...

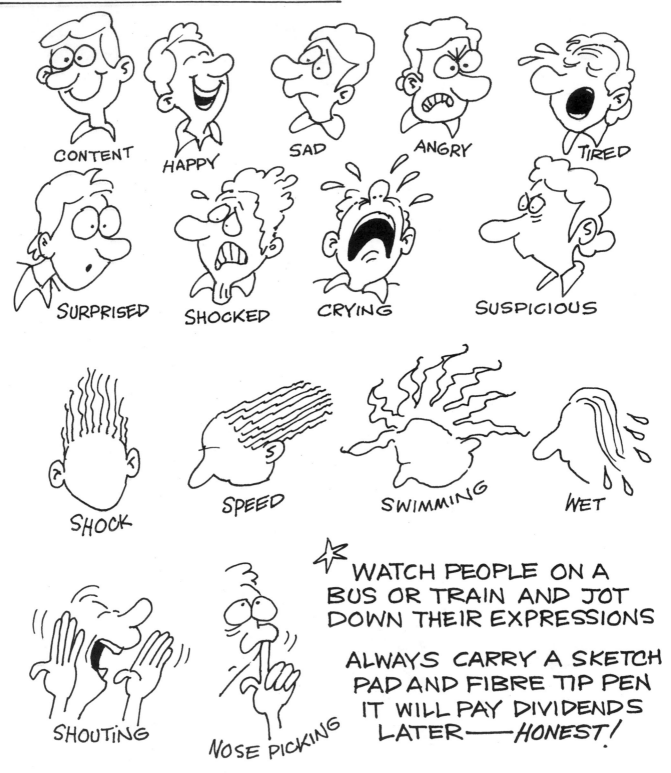

CONTENT

HAPPY

SAD

ANGRY

TIRED

SURPRISED

SHOCKED

CRYING

SUSPICIOUS

SHOCK

SPEED

SWIMMING

WET

SHOUTING

NOSE PICKING

☆ WATCH PEOPLE ON A BUS OR TRAIN AND JOT DOWN THEIR EXPRESSIONS

ALWAYS CARRY A SKETCH PAD AND FIBRE TIP PEN IT WILL PAY DIVIDENDS LATER——HONEST!

Hands

ARE VERY IMPORTANT IN THE ART OF DRAWING CARTOONS, THEY HELP A CHARACTER TO EXPRESS ITSELF—SO DON'T TRY AND HIDE THEM BECAUSE YOU FIND THEM DIFFICULT TO DRAW. WORK ON THEM UNTIL YOU HAVE MASTERED THE KNACK AND WATCH YOUR CHARACTERS COME TO LIFE AS THEY EXPRESS WHAT THEY ARE TRYING TO SAY WITH THEIR HANDS...

IT'S IMPORTANT, SO WORK ON IT!

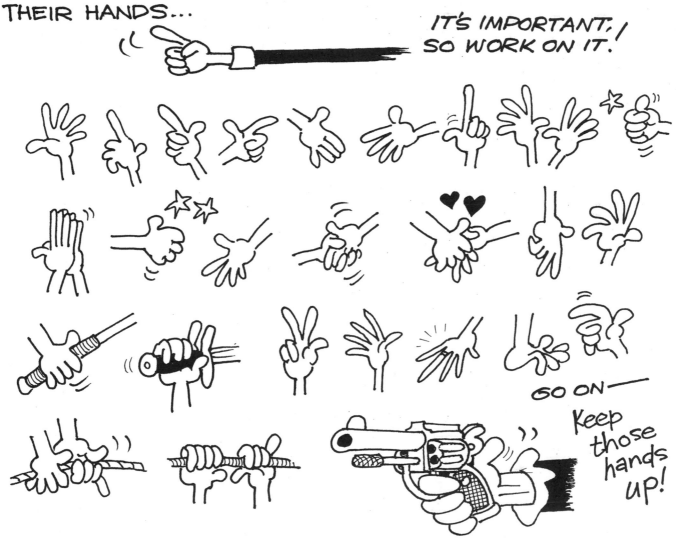

GO ON—

Keep those hands UP!

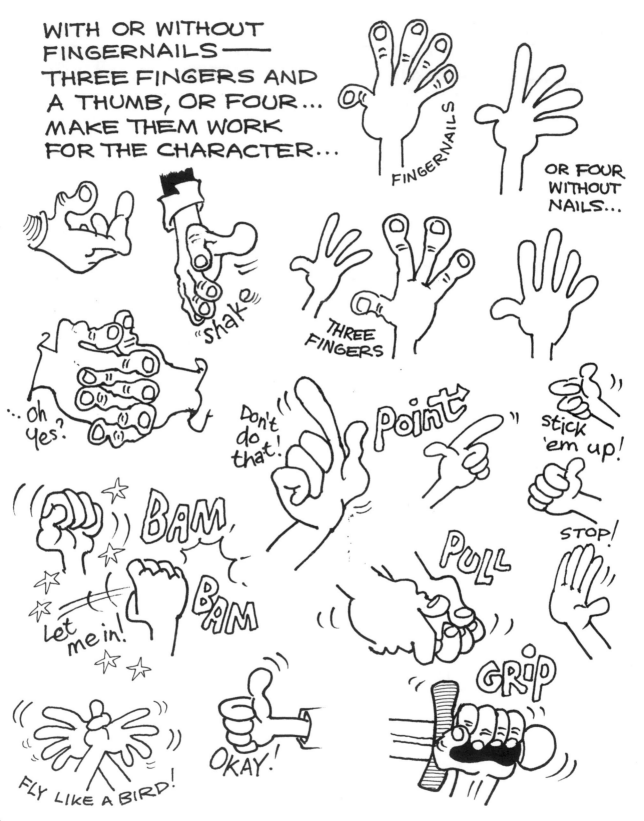

WITH OR WITHOUT
FINGERNAILS—
THREE FINGERS AND
A THUMB, OR FOUR...
MAKE THEM WORK
FOR THE CHARACTER...

FINGERNAILS

OR FOUR
WITHOUT
NAILS...

"shake

THREE
FINGERS

...oh
yes?

Don't
do
that!

Point

stick
'em up!

BAM

BAM

Let
me in!

PULL

STOP!

FLY LIKE A BIRD!

OKAY!

GRIP

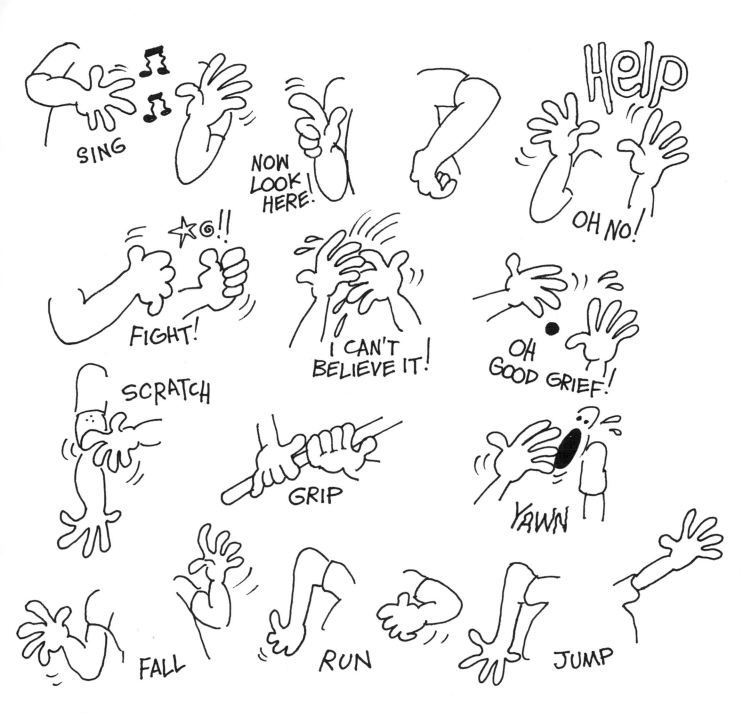

THINK OF A SITUATION OR A PIECE OF ACTION
AND THEN DRAW IT—WHEN YOU CAN DO IT
LIKE HANDWRITING, YOU ARE A CARTOONIST!

DON'T IGNORE DRAWING FEET,
THESE ARE THE FUNNIEST PART OF
THE ANATOMY—YOU CAN GET A
LOT OF HUMOUR OUT OF FEET...

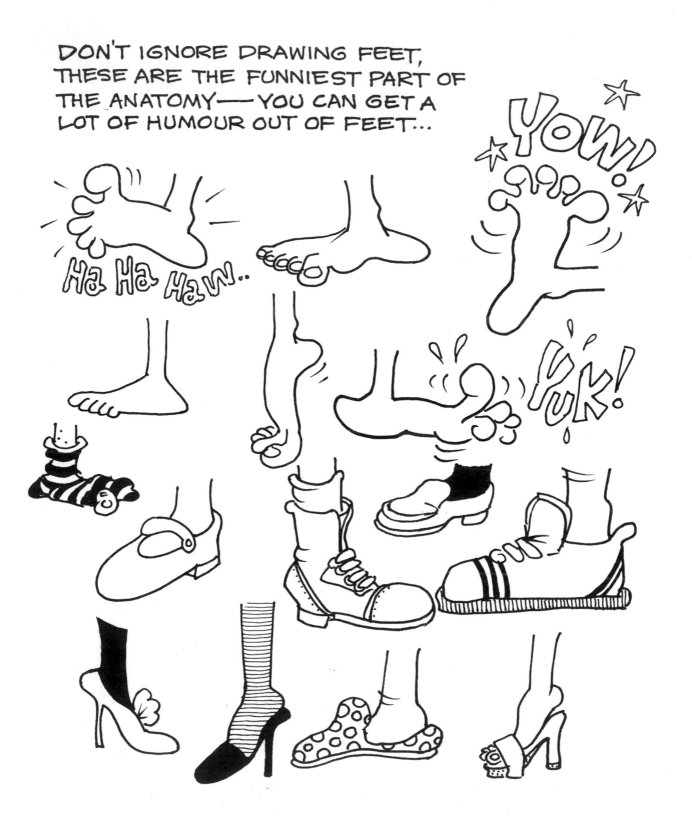

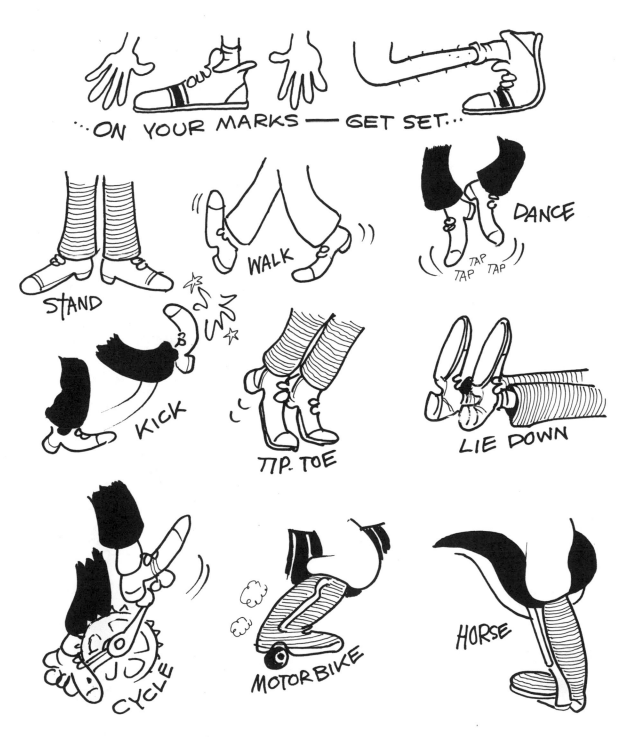

...ON YOUR MARKS — GET SET...

STAND

WALK

DANCE

TAP TAP TAP

KICK

TIP-TOE

LIE DOWN

CYCLE

MOTORBIKE

HORSE

ACTIVE FEET CAN ALSO TELL A STORY
IDENTIFYING THE CHARACTER EITHER
BY THE ACTION OR THE DRESS...

STEREOTYPES — THESE ARE PEOPLE EASILY RECOGNISED BY THEIR CLOTHES — VERY IMPORTANT FOR THE CARTOONIST — WE DON'T HAVE TO EXPLAIN WHO IS COMING THROUGH THE WINDOW, EVERY READER KNOWS WHO IT IS...

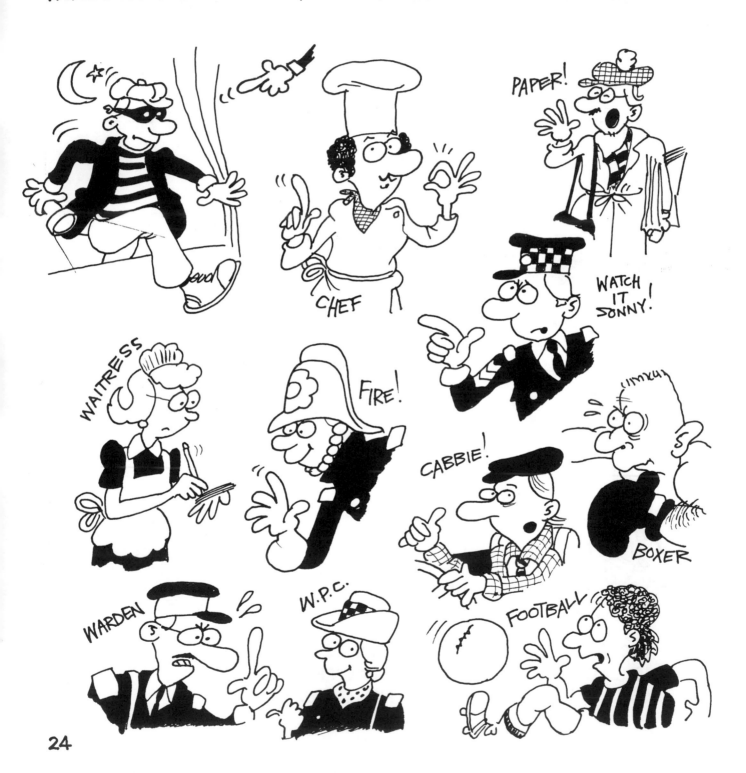

HERE IS AN EXAMPLE OF THE USE OF
STEREOTYPES IN A CARTOON PLUS THE
USE OF HANDS AND ACTION — ONE
STANDING, ONE KNEELING AND ONE SITTING.
YOU DON'T NEED A CAPTION BECAUSE THE
CHARACTER'S UNIFORMS TELL THE STORY...

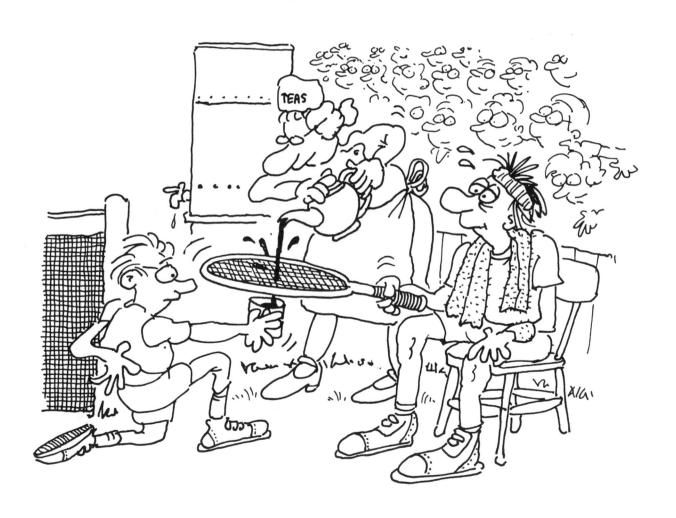

MAKE GOOD USE OF BLACK & WHITE...

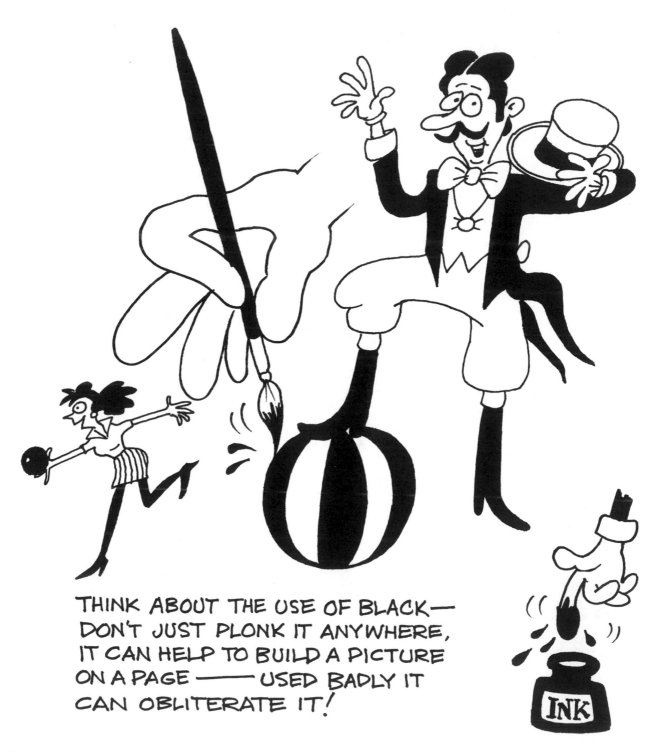

THINK ABOUT THE USE OF BLACK—
DON'T JUST PLONK IT ANYWHERE,
IT CAN HELP TO BUILD A PICTURE
ON A PAGE —— USED BADLY IT
CAN OBLITERATE IT!

SOLID BLACK

THESE CARTOONS ALWAYS REPRODUCE WELL BECAUSE OF THE CONTRAST OF SOLID BLACK AND THE OPEN LINE DRAWING...

IT'S ALWAYS A BIT TRICKY KNOWING WHEN TO LEAVE WELL ALONE——

BUT AS THESE TWO EXAMPLES ARE MAKING USE OF THE BLACK TO MAKE THE POINT OF THE CARTOON— IT'S EASIER...

*

USE A BRUSH AND BLACK INK TO FILL IN...

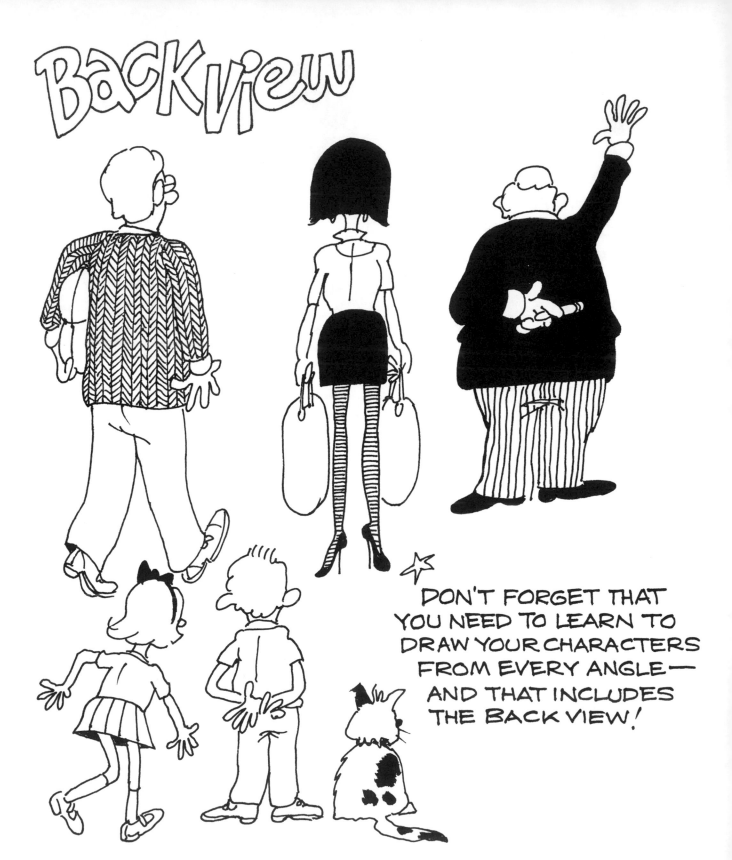

Back view

DON'T FORGET THAT YOU NEED TO LEARN TO DRAW YOUR CHARACTERS FROM EVERY ANGLE— AND THAT INCLUDES THE BACK VIEW!

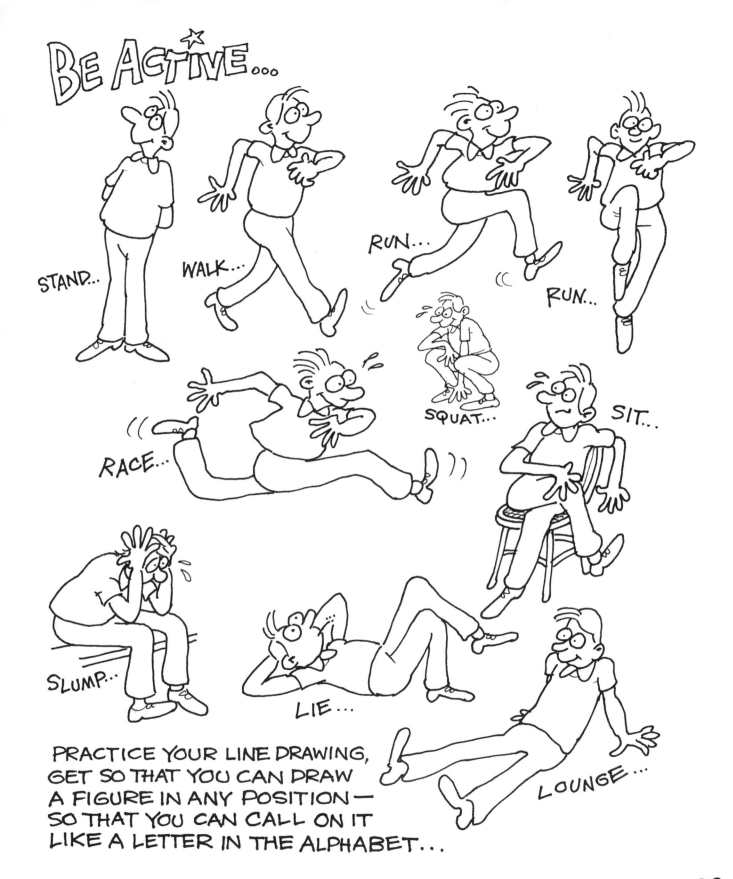

BE ACTIVE...

STAND...

WALK...

RUN...

RUN...

RACE...

SQUAT...

SIT...

SLUMP...

LIE...

LOUNGE...

PRACTICE YOUR LINE DRAWING,
GET SO THAT YOU CAN DRAW
A FIGURE IN ANY POSITION —
SO THAT YOU CAN CALL ON IT
LIKE A LETTER IN THE ALPHABET...

ABOVE ALL—BE ACTIVE!

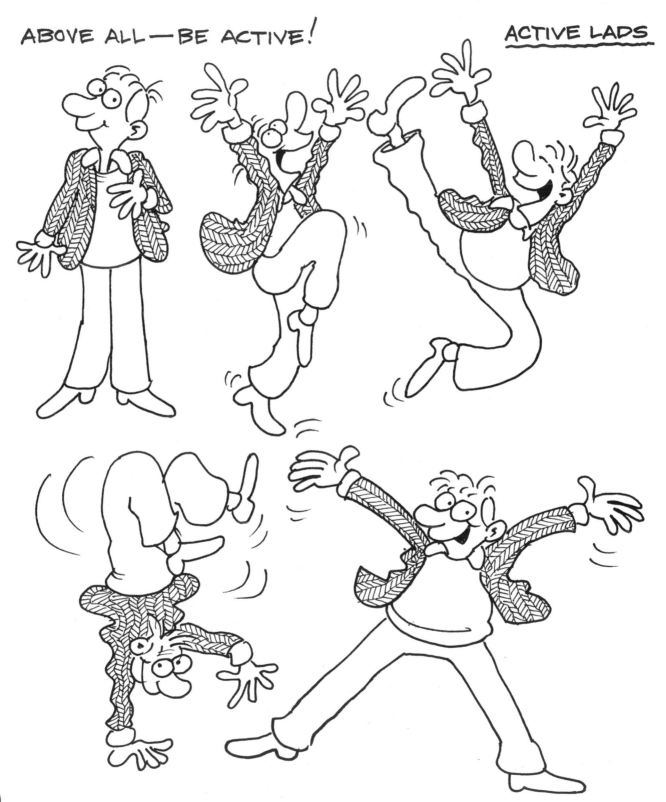

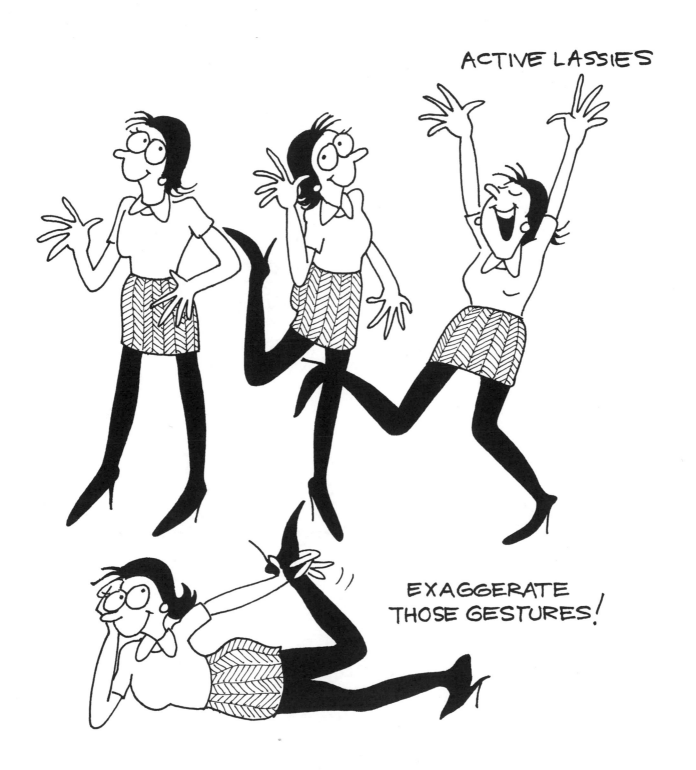

ACTIVE LASSIES

EXAGGERATE
THOSE GESTURES!

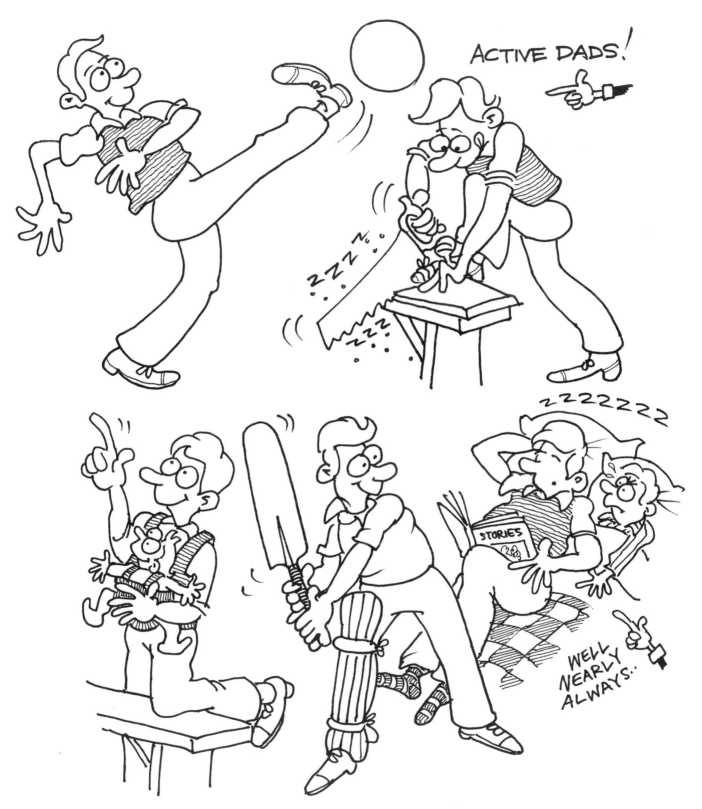

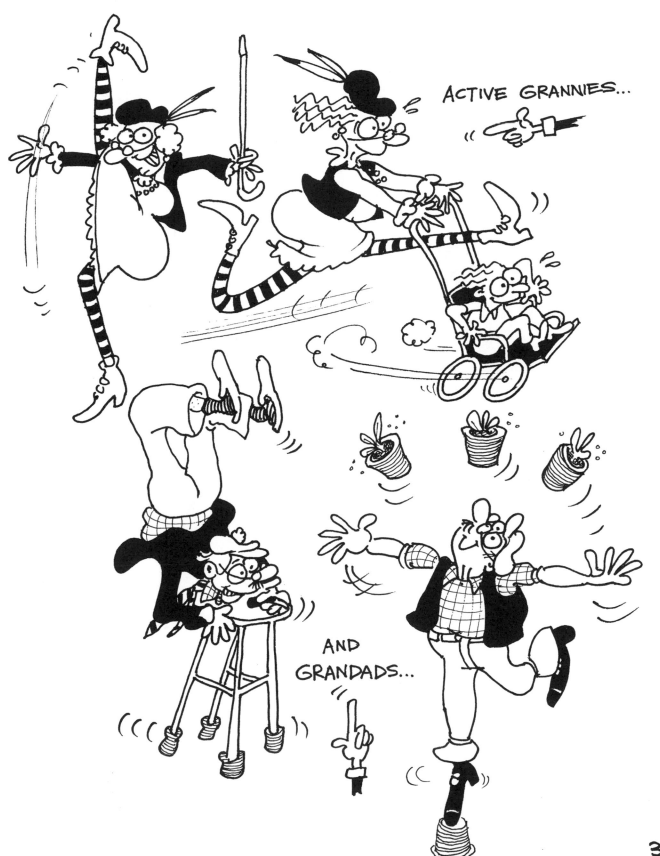

ACTIVE GRANNIES...

AND GRANDADS...

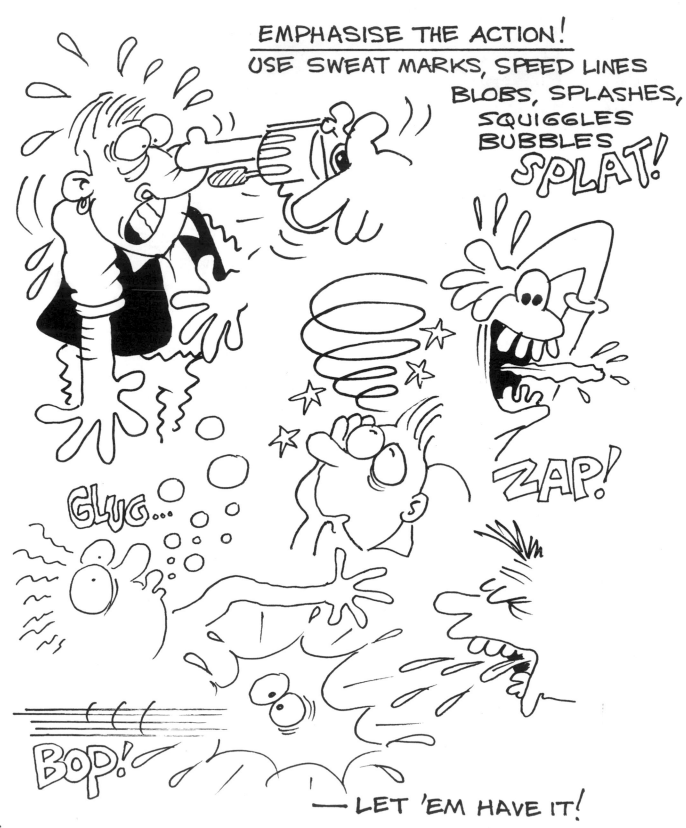

34

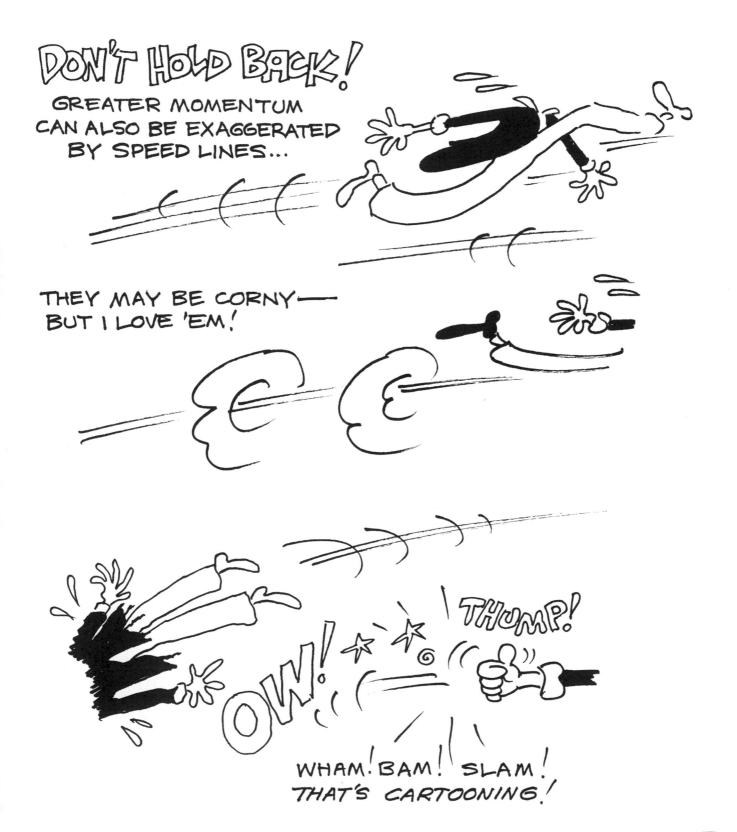

DON'T HOLD BACK!
GREATER MOMENTUM CAN ALSO BE EXAGGERATED BY SPEED LINES...

THEY MAY BE CORNY— BUT I LOVE 'EM!

OW! THUMP!

WHAM! BAM! SLAM! THAT'S CARTOONING!

YOU CAN NEVER DO ENOUGH FIGURE DRAWING—
LEARN TO DRAW EVERY ACTION, EVEN IF IT'S ONLY
A QUICK ROUGH, JOT IT DOWN IN PENCIL AND THEN
WORK IT OUT AS A FINISHED PEN DRAWING LATER.

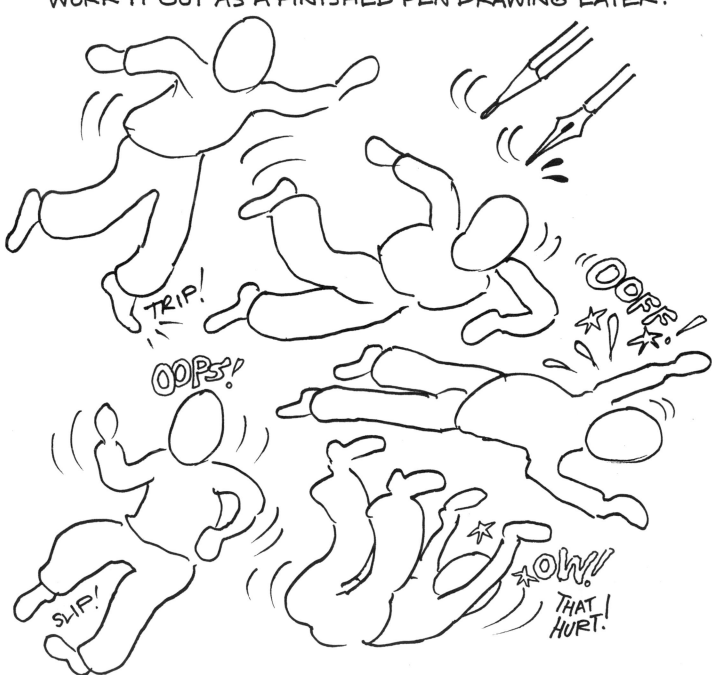

BODY WORK...

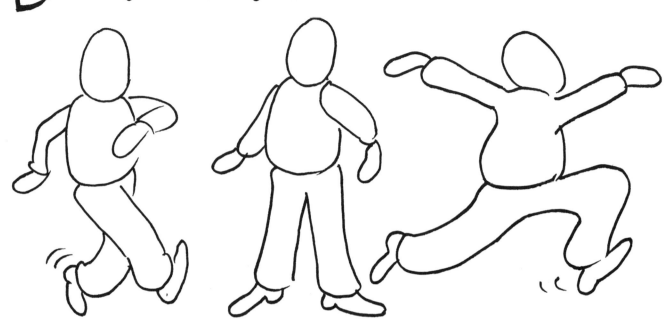

A CARTOON FIGURE IS NOT LIKE
A NORMAL HUMAN SIZE — A REAL
PERSON IS ABOUT SEVEN HEADS HIGH,
A CARTOON FIGURE IS ABOUT 4½

IS THAT ALL?

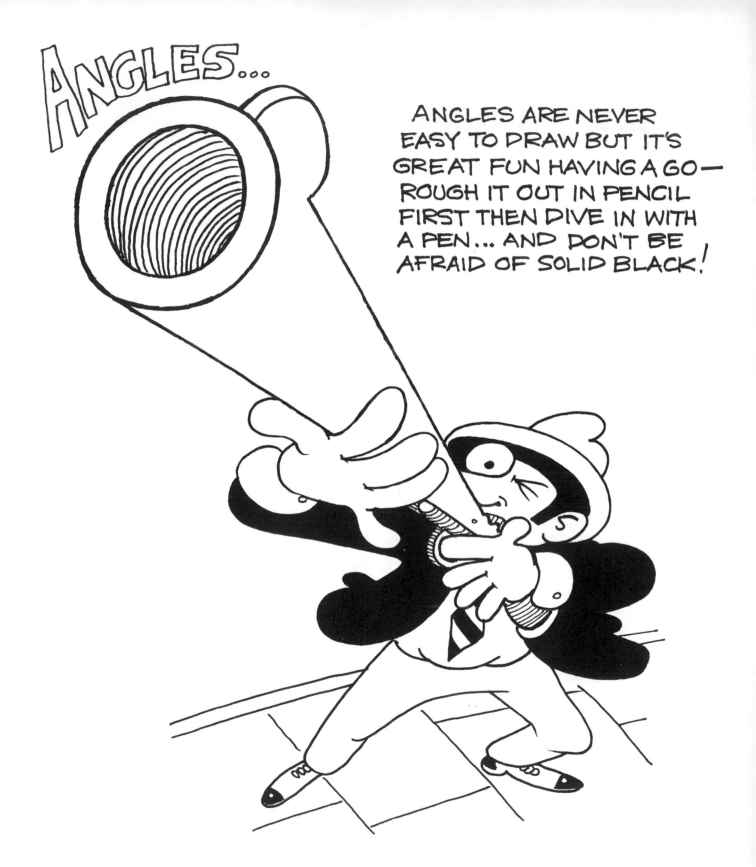

ANGLES ARE NEVER
EASY TO DRAW BUT IT'S
GREAT FUN HAVING A GO —
ROUGH IT OUT IN PENCIL
FIRST THEN DIVE IN WITH
A PEN... AND DON'T BE
AFRAID OF SOLID BLACK!

DON'T BE AFRAID TO TRY SOME UNUSUAL ANGLES,
IT'S DIFFICULT AND YOU MAY HAVE TO DRAW
AND RE-DRAW— BUT IT MAKES YOUR
WORK MORE INTERESTING TO LOOK AT

—IT CAN BE A BIT
OF A NIGHTMARE, BUT TRY IT!

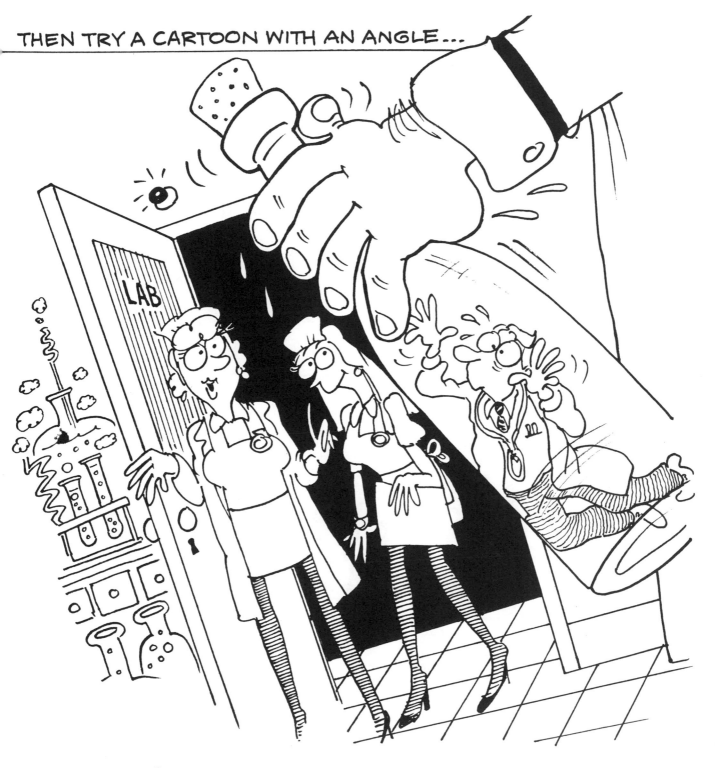

"PROFESSOR — HAVE YOU SEEN THAT YOUNG HANDSOME HOUSE DOCTOR AROUND?"

PERSPECTIVE ALWAYS LOOKS COMPLICATED
YET IT IS REALLY QUITE SIMPLE — A COUPLE
OF PENCIL LINES DRAWN LIGHTLY WITH A RULER
WILL GIVE YOU A GUIDE TO SHOW YOUR
VANISHING POINT——THE REST IS UP TO
HOW GOOD YOUR DRAWING IS...
DON'T FORGET TO RUB YOUR
PENCIL LINES OUT.

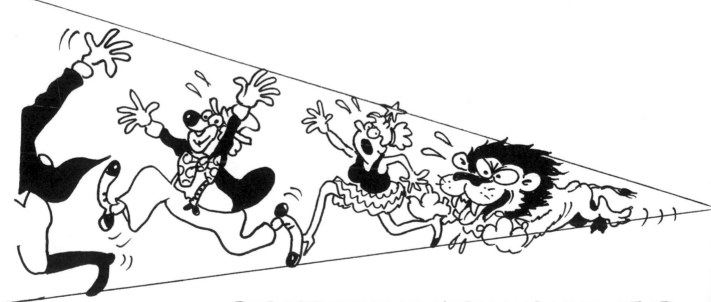

PERSPECTIVE IS VERY IMPORTANT IF
YOU'RE DRAWING A LARGE DETAILED
CARTOON——BUT DON'T LET IT WORRY
YOU TOO MUCH FOR A SINGLE COLUMN
GAG—ACTION IS MORE IMPORTANT!

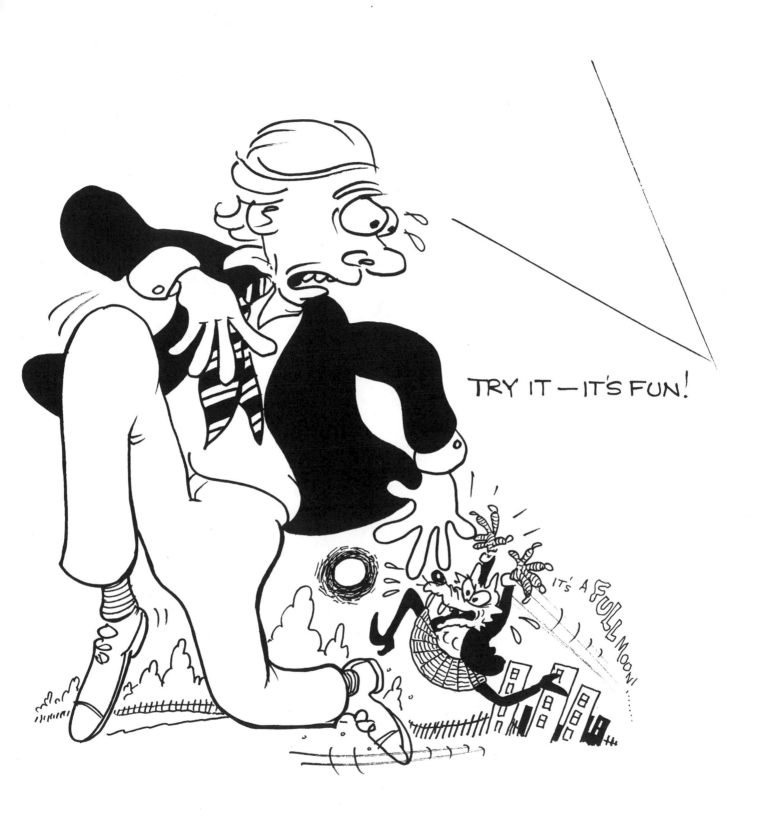

STYLE

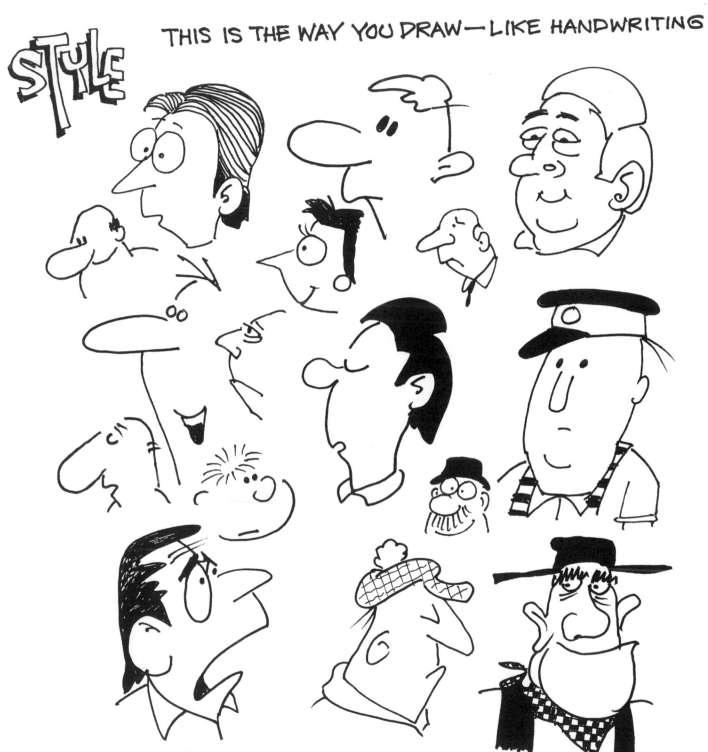

STUDY THE PROFESSIONALS AND SEE
HOW THEY HAVE DEVELOPED A STYLE ALL THEIR OWN—
THEN WORK ON DEVELOPING A STYLE OF YOUR OWN!

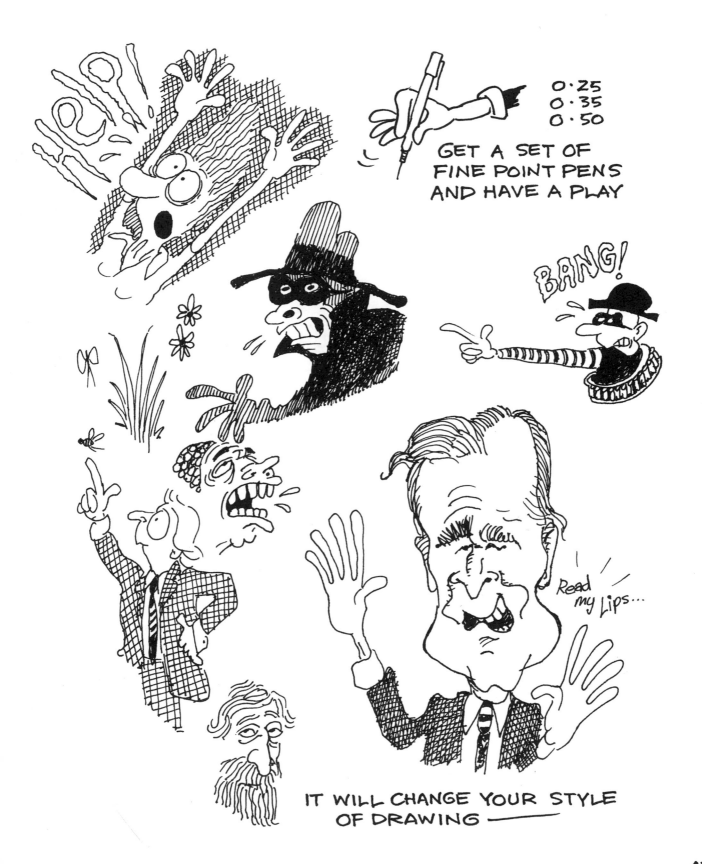

DRAWING CHILDREN...

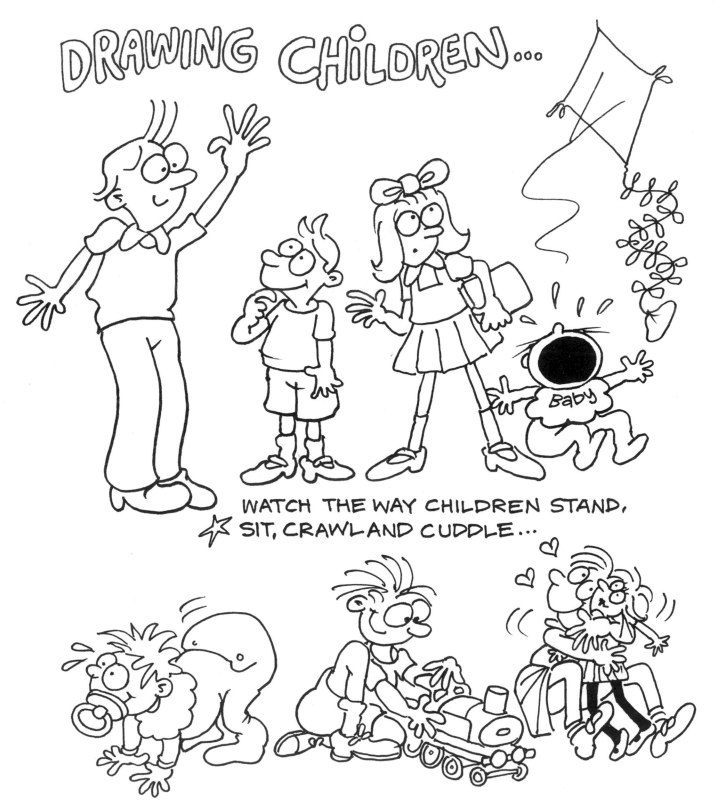

WATCH THE WAY CHILDREN STAND,
SIT, CRAWL AND CUDDLE...

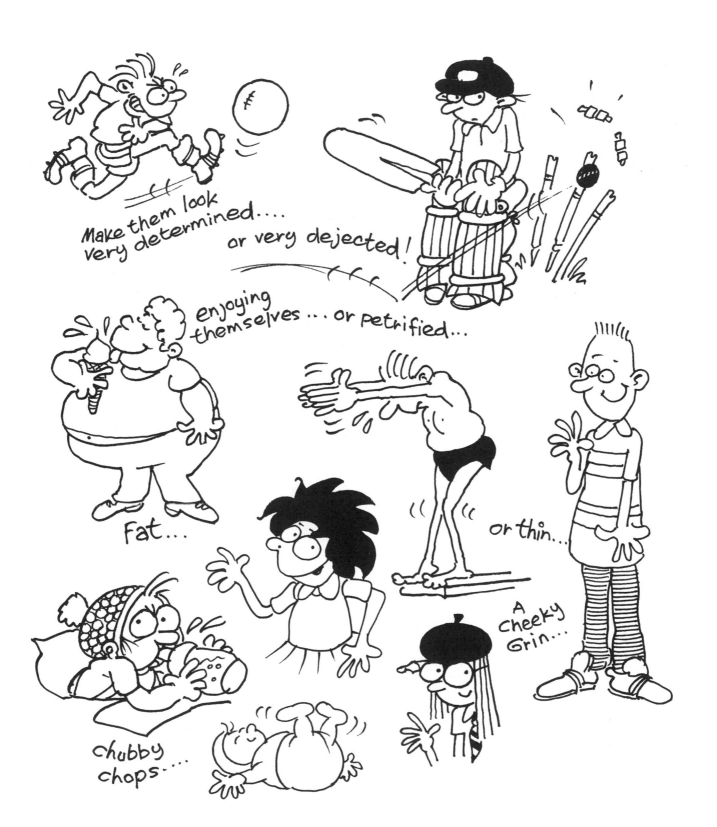

Make them look....
very determined....

or very dejected!

enjoying themselves ... or petrified...

Fat...

or thin...

A cheeky Grin...

chubby chops....

WHEN DRAWING CARTOON CHILDREN OF ALL AGES
YOU CAN FORGET ALL THE RULES ON DRAWING THE
HUMAN ANATOMY —— SOME ARE FOUR HEADS
TALL, SOME ARE TWO —
ARMS AND LEGS ARE
FORESHORTENED —
ANYTHING GOES!

BUT DO THINK OF
THE EXPRESSIONS
KEEP THEM KID-LIKE ➤

STOP
DOING THAT!

48

Drawing Costume...

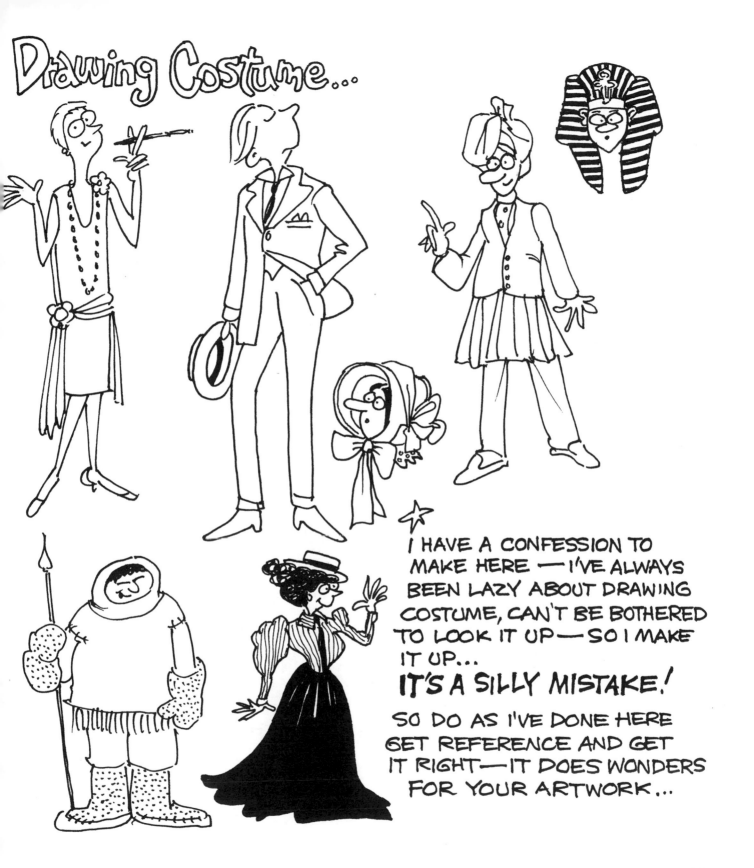

I HAVE A CONFESSION TO MAKE HERE — I'VE ALWAYS BEEN LAZY ABOUT DRAWING COSTUME, CAN'T BE BOTHERED TO LOOK IT UP — SO I MAKE IT UP...

IT'S A SILLY MISTAKE!

SO DO AS I'VE DONE HERE GET REFERENCE AND GET IT RIGHT — IT DOES WONDERS FOR YOUR ARTWORK...

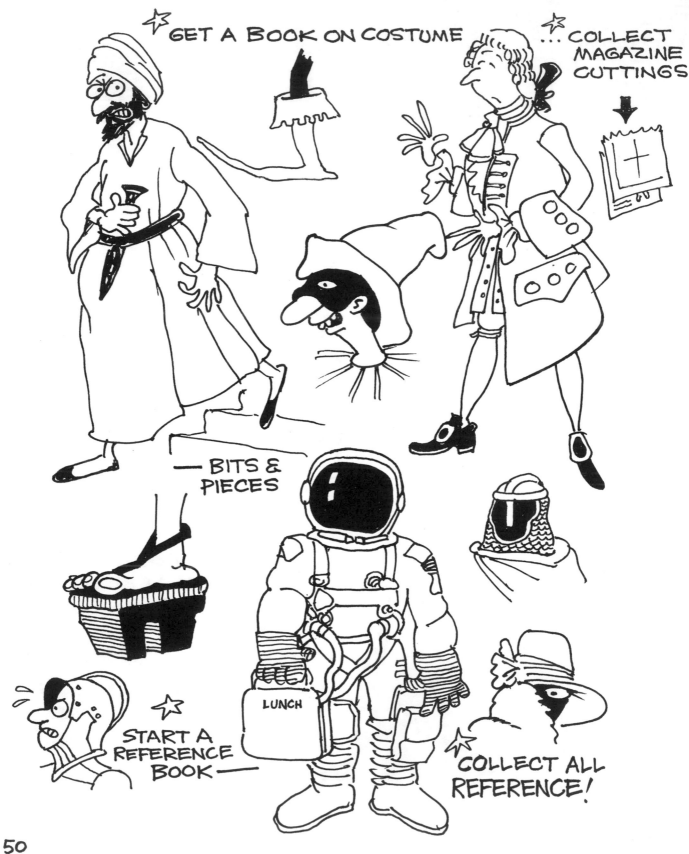

GET A BOOK ON COSTUME

... COLLECT MAGAZINE CUTTINGS

BITS & PIECES

START A REFERENCE BOOK

LUNCH

COLLECT ALL REFERENCE!

IDEAS FOR A CARTOON CAN COME EASY IF YOU ARE A
CARTOONIST—IT DOESN'T MEAN TO SAY IT'S GOING TO
BE A GOOD IDEA, THEY CAN BE GOOD, BAD OR YUK!
EITHER WAY YOU JUST HAVE TO SIT DOWN AND TURN
THEM INTO DRAWINGS ON PAPER TO SEE IF THEY WORK.
I CAN GET INTO A MORNING SESSION AND TURN OUT
A DOZEN CARTOONS — SIX OF WHICH I AM HAPPY
WITH — THREE OF THEM I WILL PROBABLY SELL...
(AND NOT ALWAYS THE BEST ONES) OH WELL...//

"HE'S NOT SWASHBUCKLING — HE'S SHOWING OFF!"

IDEAS WILL ATTACK YOU AT ALL TIMES, SO BE PREPARED AND ALWAYS HAVE PEN AND PAPER HANDY IF YOU GET A GREAT IDEA FOR A GAG JUST AS YOU ARE DOZING OFF FOR A NIGHTS SLEEP — DON'T TRY AND SHOVE IT TO THE BACK OF YOUR MIND UNTIL THE MORNING BECAUSE YOU WILL LOSE IT — GET OUT OF BED AND PUT IT DOWN ON PAPER...

ONCE YOU'VE TRAINED YOUR MIND TO THINK CARTOONS IDEAS WILL START TO FLOW——BUT NEVER DISMISS AN IDEA COMPLETELY, PUT IT DOWN ON PAPER AND GET IT OUT OF THE SYSTEM—YOU CAN'T BE BRILLIANT ALL THE TIME AND SOMEBODY WILL LAUGH AT IT (HONESTLY)

TO START THE BRAIN CELLS OFF TRY THINKING OF THEMES, OR MOMENTS IN HISTORY, FAMOUS PEOPLE, JOB SITUATIONS, COOKERY——ANYTHING TO TRIGGER OFF THE IMAGINATION——DON'T SIT THERE STARING INTO SPACE WAITING FOR GENIUS...IT WON'T COME, YOU HAVE TO WORK FOR IT—AND SOMETIMES TAKE SECOND BEST...

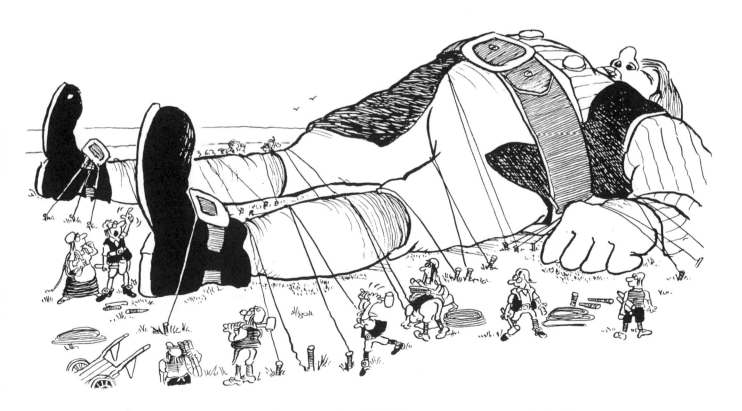

"HIS NAME IS WRITTEN ON THE SOLE OF HIS BOOT —IT'S FREEMAN HARDY & WILLIS!"

SOME IDEAS WILL COME THAT NEED SPACE — PLUS A LOT OF WORK — DON'T HANG BACK... LET IT RIP!

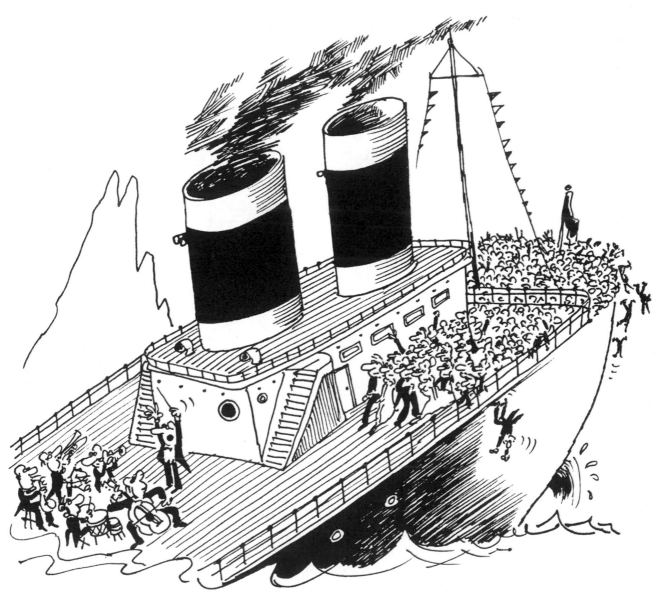

MAKE THIS THE LAST WALTZ — THEY'RE GETTING RESTLESS...

A GOOD IDEA HAS ITS OWN REWARD — HOWEVER, GET UP AND GIVE YOURSELF A TREAT — PUT THE KETTLE ON!

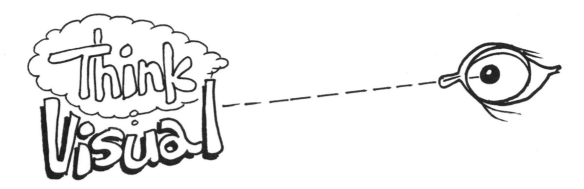

IDEAS WILL COME IF YOU SIT AND THINK ABOUT THEM — BUT DON'T JUST THINK IN WORDS, A GOOD CARTOON SHOULDN'T NEED WORDS IT CAN ALL BE CONTAINED IN A DRAWING TRAIN YOURSELF TO THINK THIS WAY AND YOU WON'T GO FAR WRONG...

IF YOU JUST KEEP ON DRAWING TWO PEOPLE TALKING TO EACH OTHER IT ISN'T REALLY A CARTOON — YOU COULD PRINT THE SAME DRAWING EVERY DAY AND WRITE A DIFFERENT CAPTION — SO MAKE SURE THAT THE ARTWORK TELLS THE STORY AND NOT THE WRITING UNDERNEATH...

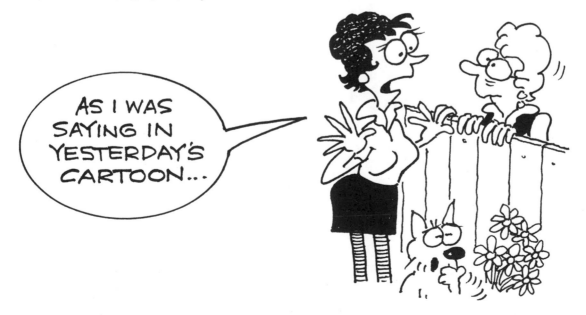

AS I WAS SAYING IN YESTERDAY'S CARTOON...

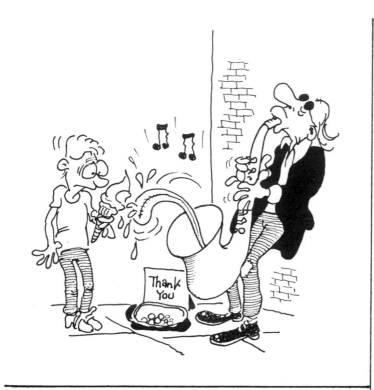

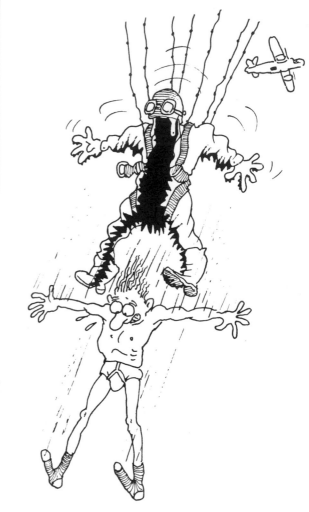

☆ THINK VISUAL

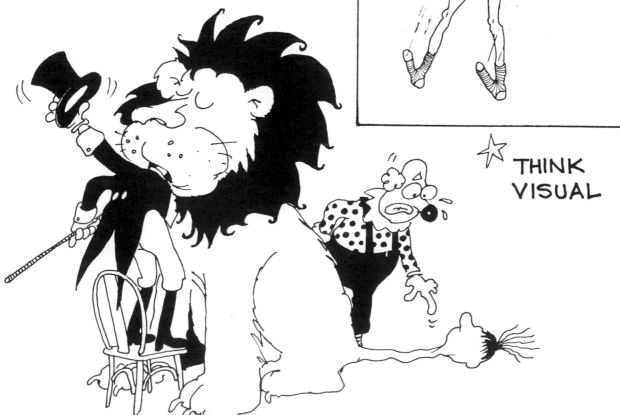

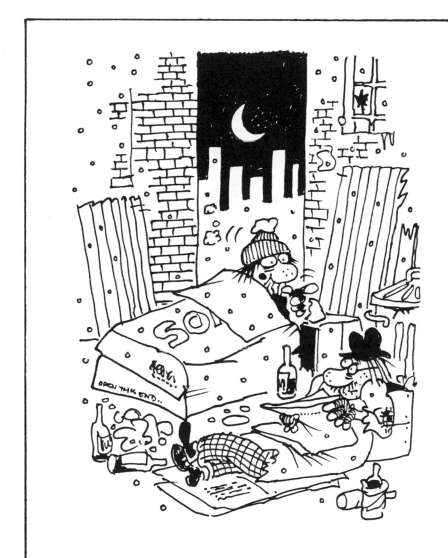

"READ THAT PIECE ON GLOBAL
WARMING TO ME AGAIN..."

THE CARTOON BELOW IS THE SIZE I DRAW FOR
A FRONT PAGE TOPICAL CARTOON, SINGLE COLUMN.

I USED A ROTORING PEN 0.50 FOR THIS DRAWING
I DON'T PENCIL — I DRAW DIRECT — IF I GET IT
WRONG THEN I DRAW IT AGAIN...

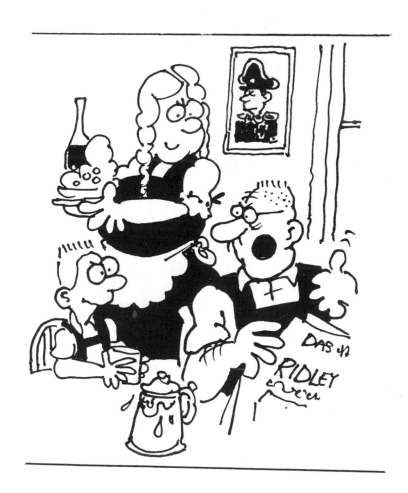

"THE ENGLISH CAN NEVER FORGET
THAT BACK IN 1945 WE GERMANS
ALMOST LOST THE WAR..."

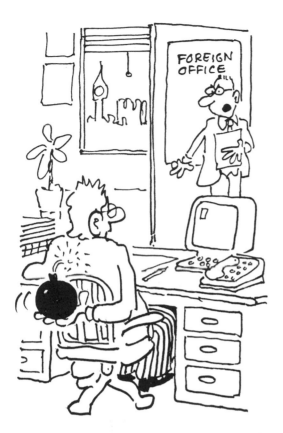

"DO YOU BELIEVE THIS RUBBISH ABOUT THERE BEING A FIFTH MAN?"

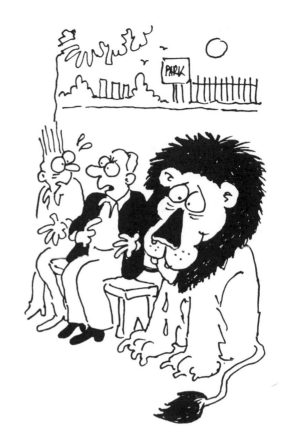

"WHY NOT?—DOGS ARE BECOMING SO DANGEROUS TO KEEP THESE DAYS"

TOPICAL CARTOONS ARE HARD WORK—PARTICULARLY IF YOU ARE DOING A DAILY ONE. YOU HAVE TO KEEP UP WITH THE NEWS AND MAKE SURE YOU PICK A SUBJECT THAT YOUR READERS ARE AWARE OF— IT'S NO GOOD DOING A GAG ON A VERY FUNNY SUBJECT IF YOU ARE THE ONLY PERSON WHO KNOWS ABOUT IT. ALSO WHEN DOING TOPICAL GAGS YOU WILL FIND THAT YOUR EDITOR LIKES A CHOICE OF SUBJECT—SO YOU NEED TO ENTER HIS OFFICE WITH AT LEAST A CHOICE OF FOUR—AND IF IT'S A GOOD DAY FOR NEWS—SIX!

TRY TO KEEP YOUR CAPTIONS AS BRIEF AS POSSIBLE—
NOT AN EASY THING TO DO WITH TOPICAL CARTOONS
BECAUSE YOU HAVE TO MAKE SURE THAT YOUR READERS
CAN IMMEDIATELY CONNECT YOUR CARTOON WITH
THE SUBJECT MATTER IN THE NEWS—I ALWAYS
SAY THAT A READER WILL GIVE YOU AROUND TEN
SECONDS TO DO THIS BEFORE HE OR SHE TURNS
THE PAGE...

...FOUR, FIVE,
SIX, SEVEN, EIGHT, NINE.... 'BYE!

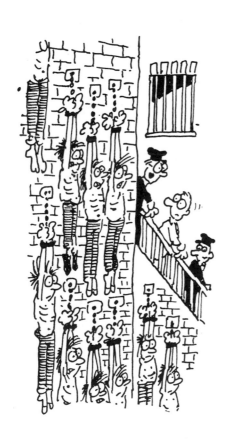

WE HAD PRISON OVERCROWDING
UNTIL WE UTILIZED OUR
WALL SPACE...

MUM, THERE'S SOMEBODY
HERE FROM THE GREEN PARTY!

SINGLE COLUMN SIZE

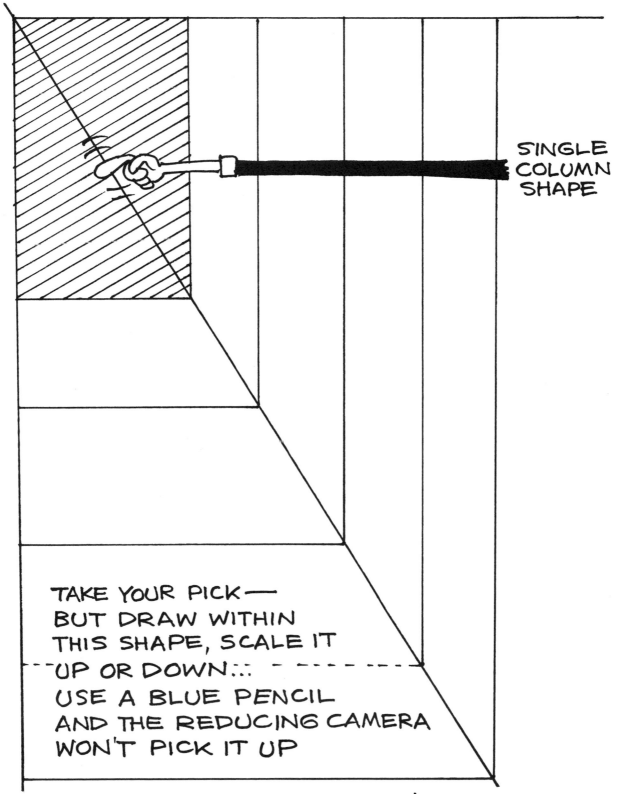

SINGLE COLUMN SHAPE

TAKE YOUR PICK—
BUT DRAW WITHIN
THIS SHAPE, SCALE IT
UP OR DOWN...
USE A BLUE PENCIL
AND THE REDUCING CAMERA
WON'T PICK IT UP

P.S. THIS SIZE CAN ALSO INCLUDE THE CAPTION!

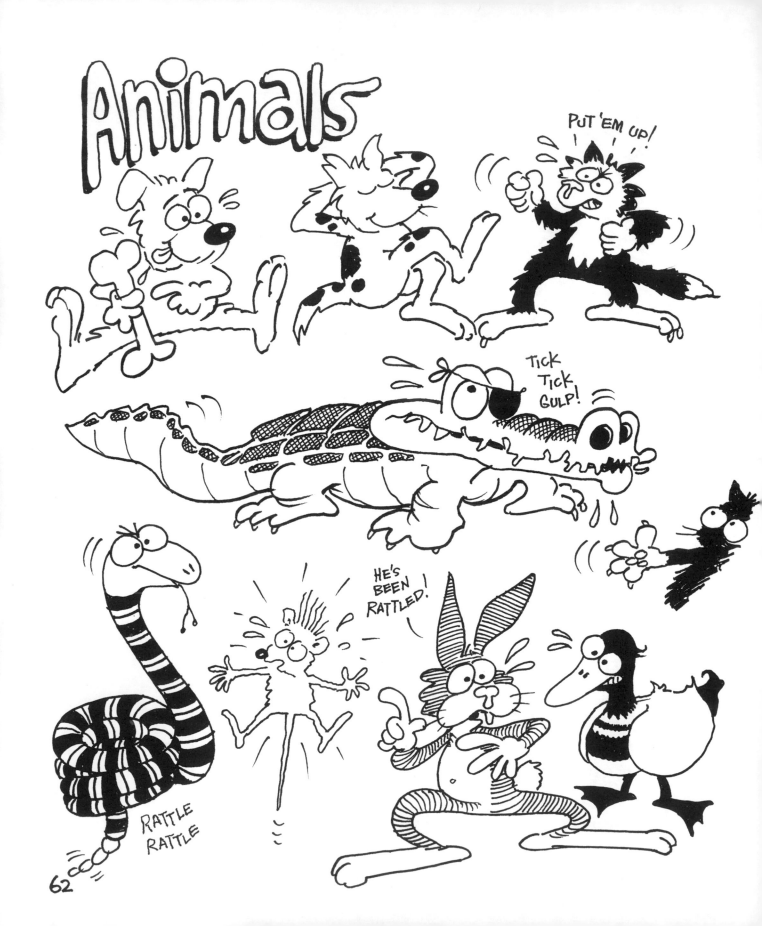

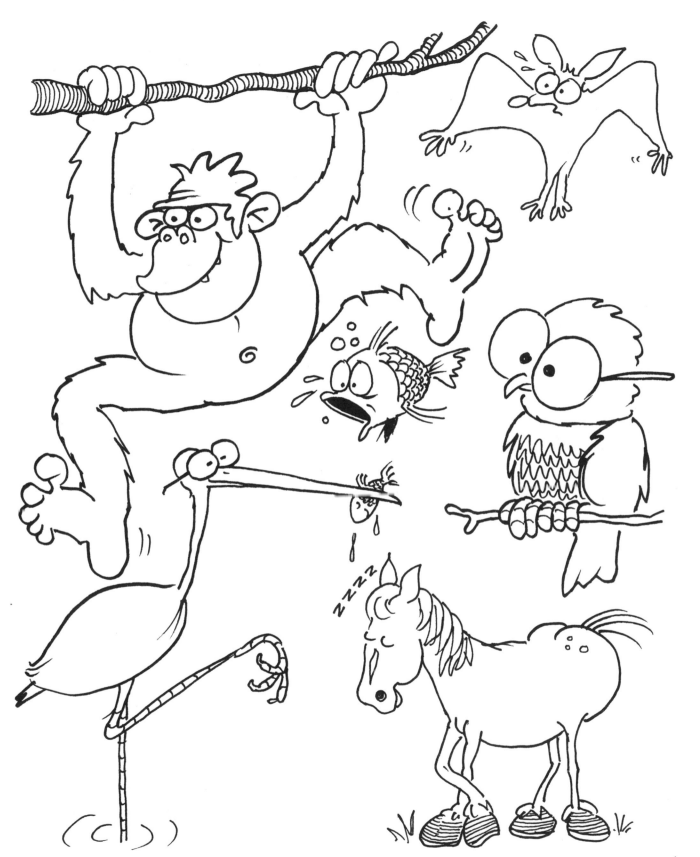

WHEN DRAWING ANIMALS
THINK ABOUT THEIR FEET—
THERE'S A LOT OF
DIFFERENT SHAPES
SO MAKE SURE YOU'VE
GOT THE RIGHT ONE...

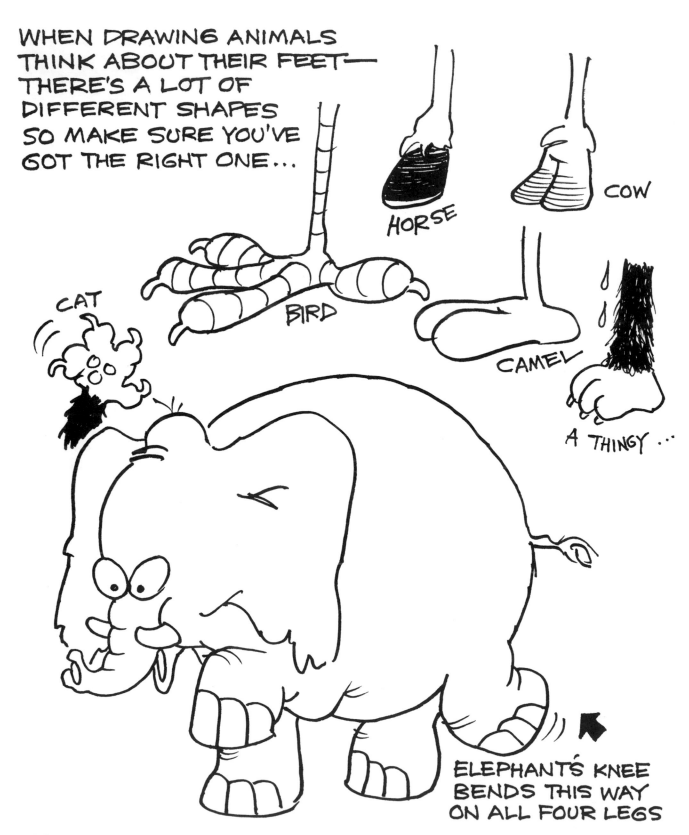

HORSE

COW

CAT

BIRD

CAMEL

A THINGY...

ELEPHANT'S KNEE
BENDS THIS WAY
ON ALL FOUR LEGS

TAKE **1** FACE!

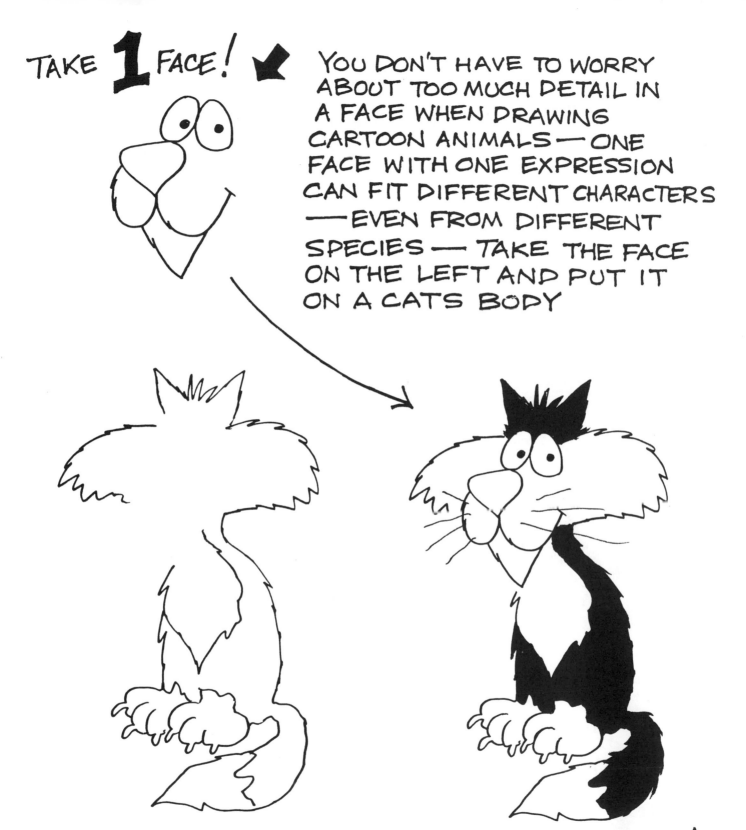

YOU DON'T HAVE TO WORRY ABOUT TOO MUCH DETAIL IN A FACE WHEN DRAWING CARTOON ANIMALS — ONE FACE WITH ONE EXPRESSION CAN FIT DIFFERENT CHARACTERS — EVEN FROM DIFFERENT SPECIES — TAKE THE FACE ON THE LEFT AND PUT IT ON A CATS BODY

YOU NOW HAVE A CARTOON CAT!

NOW TAKE THE SAME FACE AND GIVE IT THE BODY OF A DOG—— IT STILL WORKS, BUT NOW YOU HAVE A CARTOON DOG—— GO EVEN FURTHER AND TURN THE SAME FACE INTO A LION——OR A LIONESS AND HER CUB——THAT FACE HAS NOW CHANGED SEX

THAT'S *Cartooning!*

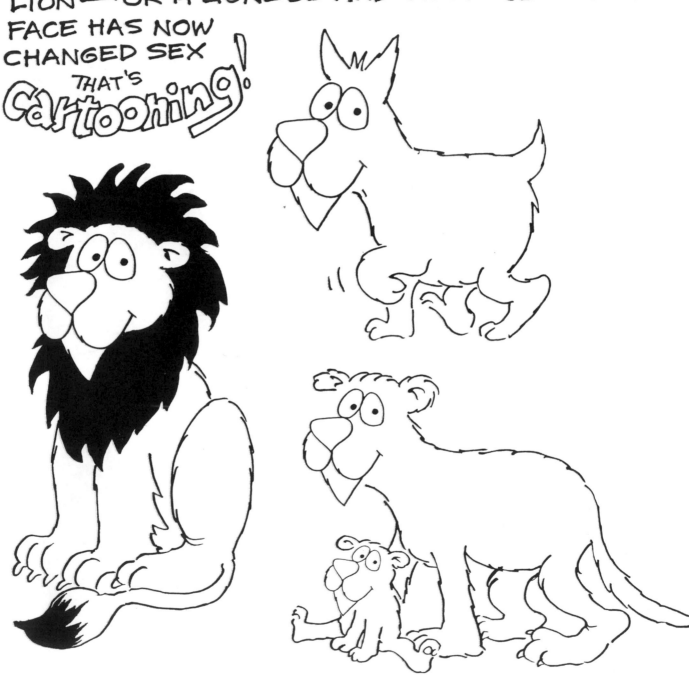

Animal Cartoons.

I LOVE DRAWING ANIMALS—FAR MORE INTERESTING THAN HUMANS, ANIMALS HAVE A CHARACTER OF THEIR OWN AS WELL AS A DIFFERENT IDENTITY—APART FROM OUR COLOUR WE ALL LOOK EXACTLY ALIKE...

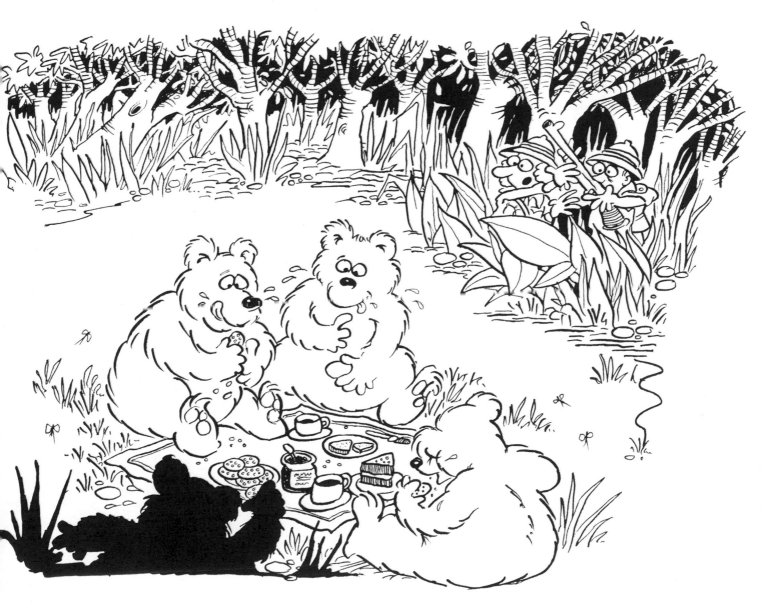

HOLD YOUR FIRE—IT'S A TEDDY BEARS PICNIC!

WALT DISNEY KNEW WHAT HE WAS DOING WHEN HE STARTED TO MAKE FILMS——HE USED ANIMALS AS HIS LEAD STARS, THERE'S A LOT MORE FUN, ANGER, PATHOS OR HYSTERIA IN GOOFY, PLUTO OR DONALD THAN ANY OF YOUR HUMAN ACTORS——AND THEY LAST MUCH LONGER, LOOK AT MICKEY MOUSE—— HE'S WELL OVER SIXTY AND HE DOESN'T LOOK A DAY OVER TWENTY TWO...

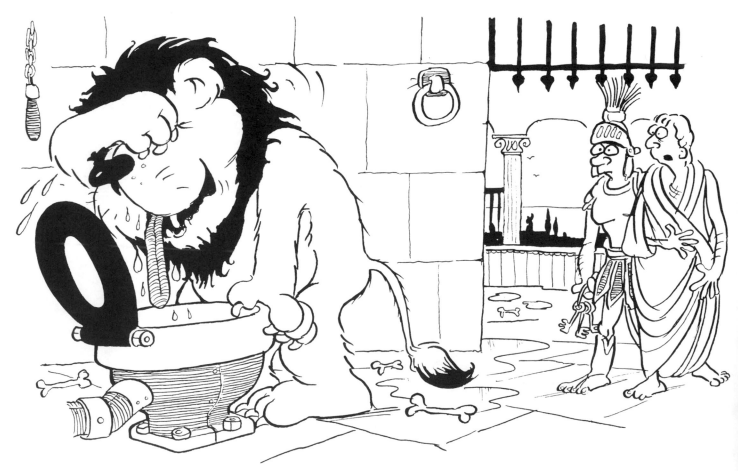

—"HAVE YOU BEEN FEEDING HIM CHRISTIANS AGAIN?"

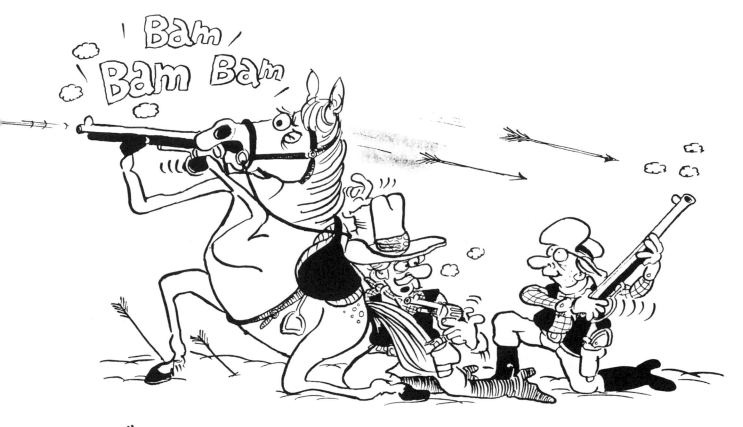

"NOW YOU KNOW WHY I CALL HIM TRIGGER.."

TAKE A SKETCH PAD TO THE ZOO AND ENJOY YOURSELF, EACH SPECIES WILL SUGGEST A CARTOON AS YOU SIT WATCHING IT MUNCHING ITS FOOD — OR JUST SITTING THERE TRYING TO WORK OUT WHAT YOU ARE STARING AT.

ANIMALS ARE ALL DIFFERENT WONDERFUL SHAPES, AND AS YOU DRAW THEM THEY TAKE ON A CHARACTER OF THEIR OWN — AND WHOEVER IT WAS WHO CALLED THEM DUMB CAN HAVE NO IMAGINATION AT ALL —— HE MUST HAVE BEEN AN ACCOUNTANT... OR WORSE STILL, A POLITICIAN...

69

HAVE FUN DRAWING ANIMALS — PUT THEM IN HUMAN
SITUATIONS AND WATCH THEM REACT—YOU CAN
GET LOTS OF GAGS THIS WAY...

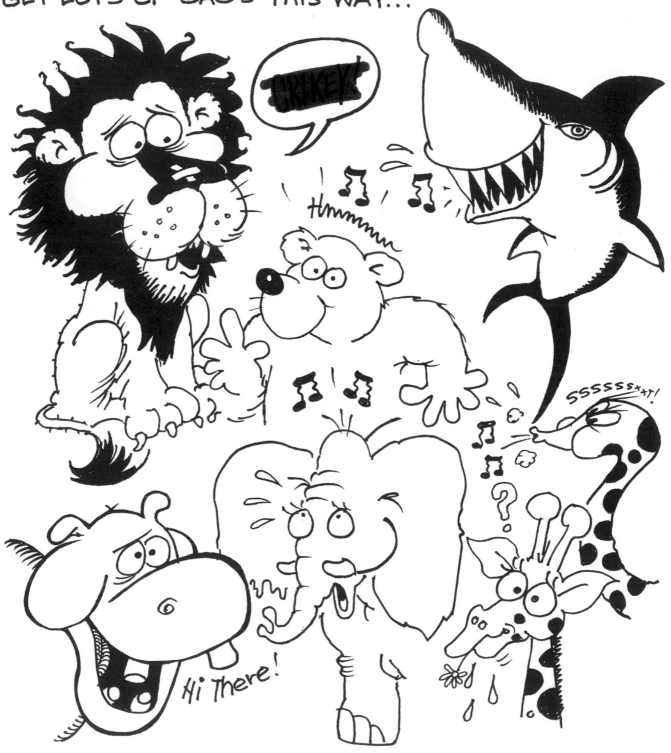

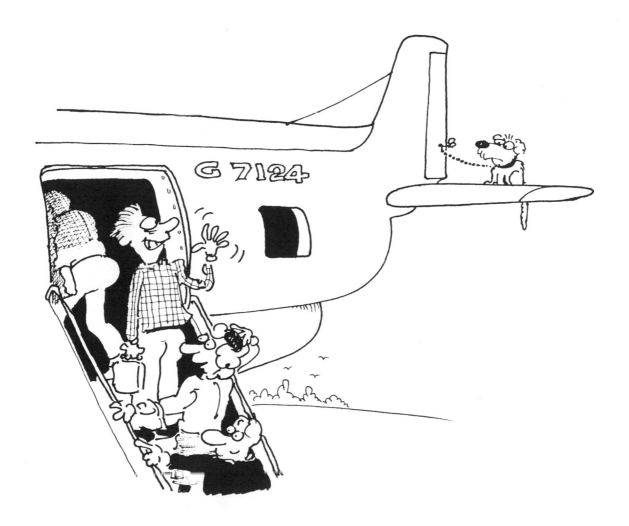

THEY ALL HAVE VOICES TO FIT THEIR LOOKS,
THINK OF AN ELEPHANT SINGING IN A
CHOIR OR A SNAKE TRYING TO WHISTLE...
A RHINOCEROS LEARNING TO TAP DANCE
WHILE A GROUP OF MONKEYS LOOKS ON.

ANIMALS CAN GIVE GREAT EXPRESSIONS—
A DOG IS A GREAT FOIL FOR A GAG...
WATCH PLUTO'S FACE NEXT TIME YOU SEE
HIM...

SNOOPY AND GARFIELD STILL ACT OUT THEIR
FANTASIES IN THE WORLD'S NEWSPAPERS —
SO TAKE YOUR PICK AND HAVE FUN WITH THE
ANIMALS — THERE'S A WEALTH OF MATERIAL
FOR IDEAS AND IT'S SITTING ON YOUR DOORSTEP
WAGGING ITS TAIL WAITING FOR YOU TO PUT
PEN TO PAPER —— I WISH YOU LUCK
WHOEVER YOU ARE, WORK ON YOUR CHARACTER,
GIVE IT A GREAT NAME AND LET RIP WITH
THE IDEAS...

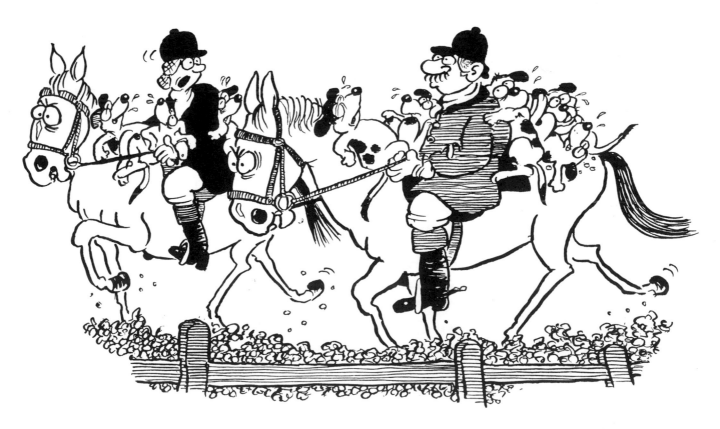

" THESE HOUNDS OF YOURS USED TO WALK HOME AFTER A HUNT!"

KEEP THE DRAWING
SIMPLE AND THE GAG
DIRECT— TRY NOT TO
LABOUR IT WITH TOO
MUCH DIALOGUE...

DRAW IT AS A STRIP,
OR A FULL PAGE
PANEL AS SHOWN...

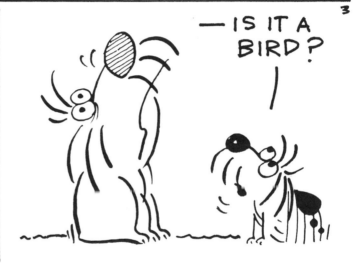

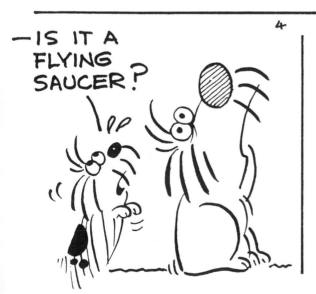

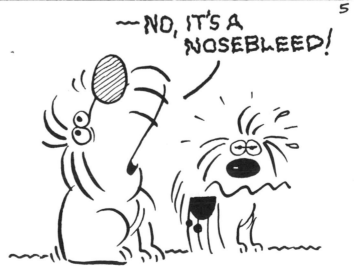

DON'T SPOIL IT WITH SLOPPY LETTERING, IF YOU CAN'T DO IT THEN JUST PENCIL IT IN UNTIL YOU CAN FIND SOMEONE WHO CAN— IT WILL LOOK SO MUCH BETTER...

1

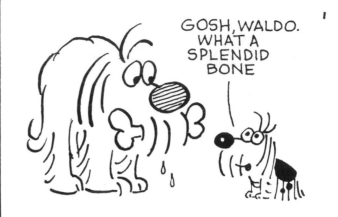

GOSH, WALDO. WHAT A SPLENDID BONE

2

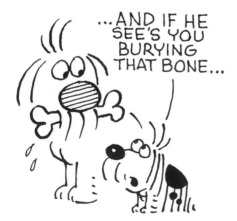

HOLD IT, HOLD IT~DON'T BURY IT YET

3

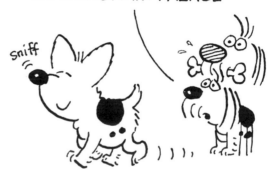

IT'S THAT CORGI FROM BUCKINGHAM PALACE

sniff

4

...AND IF HE SEE'S YOU BURYING THAT BONE...

5

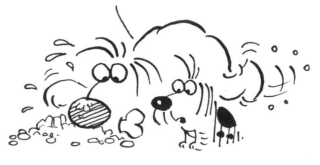

HE'S BOUND TO CLAIM TREASURE TROVE

...AND THE SAME GOES IF YOU ARE DRAWING A CARTOON THAT DEPENDS ON A SIGN BEING READ — THINK OF THE REDUCTION — WILL THE SIGN STILL READ WHEN YOUR ARTWORK IS REDUCED?

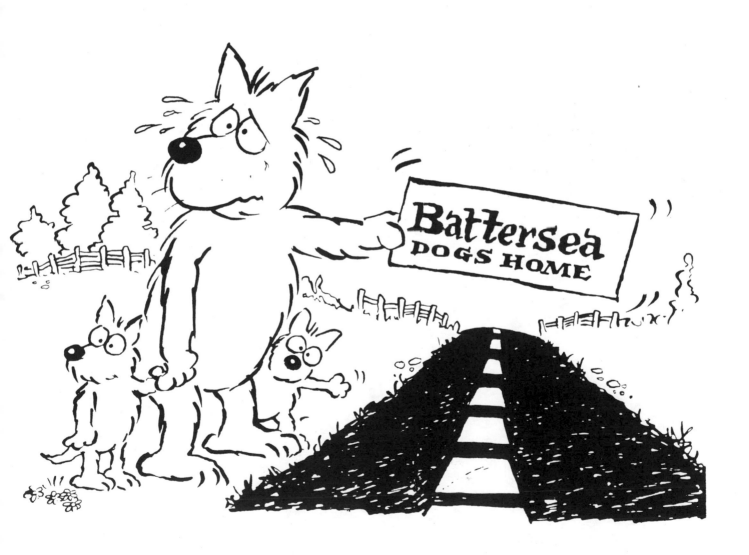

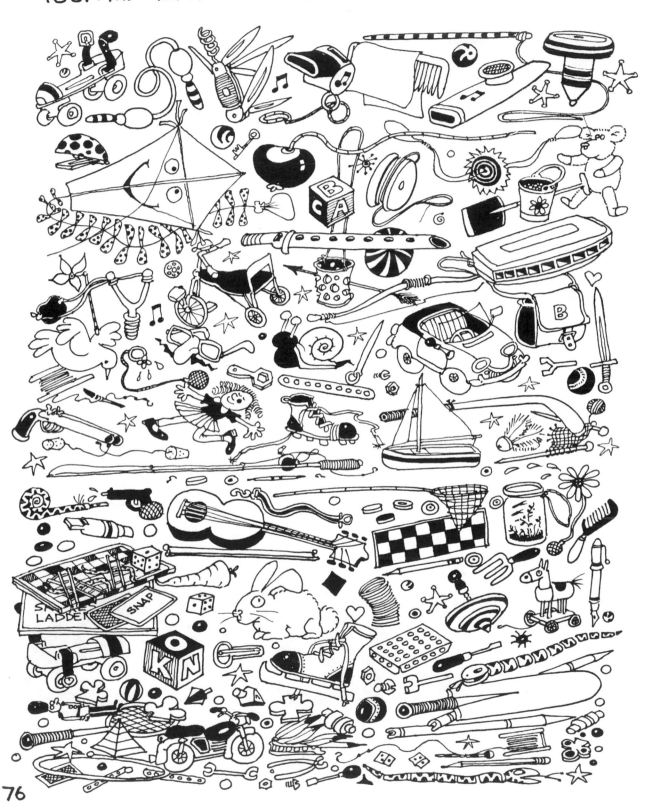

WHEN YOU SEE SOMETHING INTERESTING—AN UNUSUAL CHIMNEY POT OR A SET OF IRON RAILINGS, JOT IT DOWN ON PAPER IT WILL MAKE USEFUL REFERENCE...

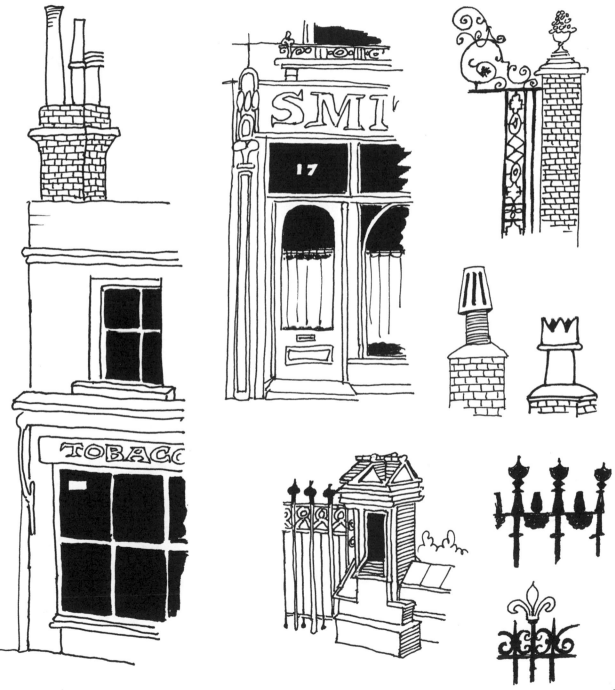

CARTOON ILLUSTRATION IS ANOTHER AREA FOR THE CARTOONIST TO USE HIS SKILLS — THIS CAN BE A STORY OR A FEATURE IN A MAGAZINE OR NEWSPAPER THAT IS SO FLAT THAT IT NEEDS DECORATION — OR THAT IT SITS ON A PAGE FULL OF TYPE AND NEEDS LIFTING WITH AN ILLUSTRATION...

— IT CAN BE FUN, BECAUSE IT'S ALL THERE IN THE ARTICLE. ALL YOU NEED TO DO IS READ IT A COUPLE OF TIMES AND PICK OUT AN ITEM TO ILLUSTRATE AND THE LAYOUT ARTIST DROPS IT IN TO BRIGHTEN HIS PAGE...

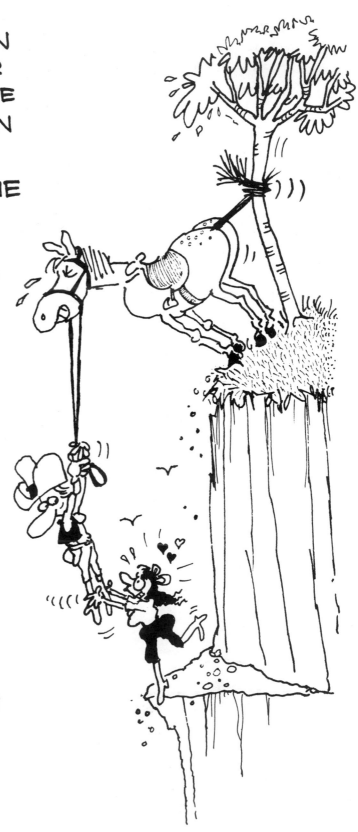

GREETINGS CARDS.

GREETINGS CARDS ARE A GOOD AREA FOR THE UP AND COMING CARTOONIST TO PRACTICE THE ART—— IN THESE WONDERFUL DAYS OF MODERN TECHNOLOGY IN PRINTING AND COPYING AT THE TOUCH OF A BUTTON, IT'S EASY TO REPRODUCE YOUR ARTWORK IN SMALL QUANTITIES FOR EVERY OCCASION...

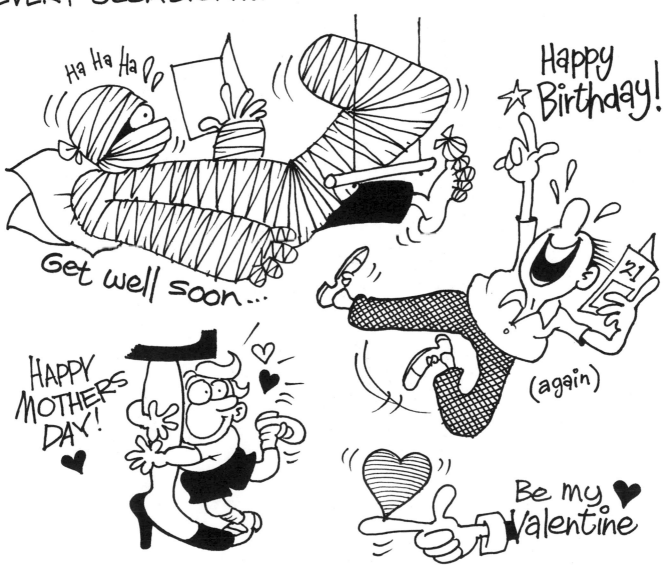

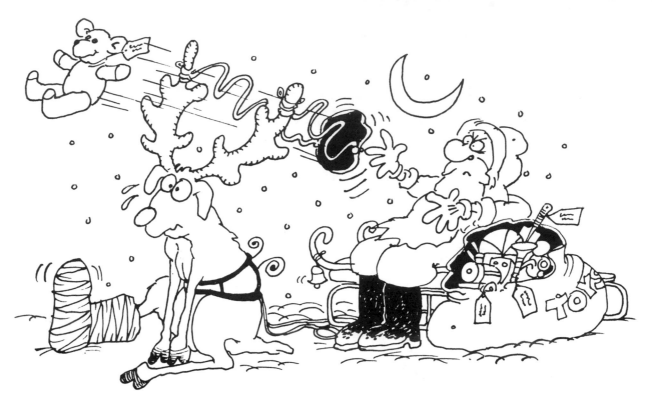

TRY DRAWING YOUR OWN CHRISTMAS CARD...

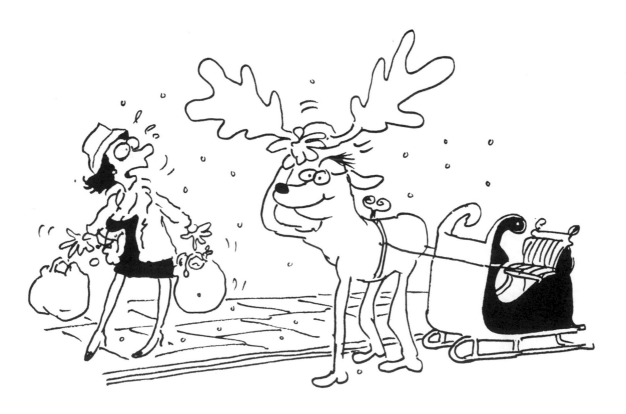

THE STRIP CARTOON

THIS IS A TECHNIQUE FOR TELLING A STORY IN PICTURES WITH SPEECH BALLOONS DAY BY DAY FOR ABOUT SIX WEEKS (THE CONTINUITY STRIP) AN IDEAL FEATURE FOR POPULAR DAILY NEWSPAPERS (YOU NEED A GOOD SCRIPT AS WELL AS A STRONG CHARACTER TO START ONE OF THESE...)

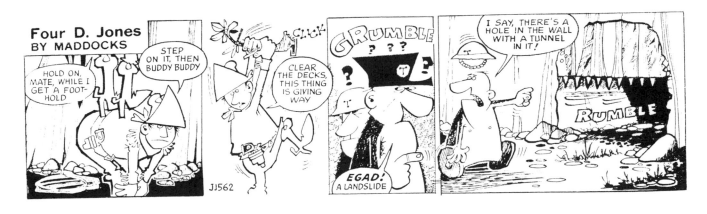

ANOTHER TECHNIQUE IS THE INSTRUCTION STRIP — COOKING — DIETS — EXCERCISES — DO-IT-YOURSELF...

OR JUST DRAWING A VISUAL CHARACTER WITHOUT
WORDS PRODUCING A ONE OFF SELF CONTAINED
GAG EVERY DAY (OR WEEK). YOU NEED TO BE VERY
SURE OF YOUR LEADING CHARACTER TO TACKLE THIS
BECAUSE AFTER A YEAR OR SO THE IDEAS FOR
VISUAL GAGS COULD WEAR A BIT THIN...

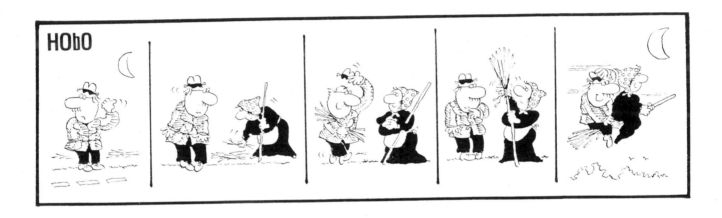

THE MOST POPULAR STRIP CARTOON TECHNIQUE IS THE
FOUR PANEL GAG A DAY STRIP SHOWING FAMILIAR
CHARACTERS IN A DAY TO DAY SITUATION AT WORK
OR PLAY (YOU NEED TWO OR THREE STRONG CHARACTERS)

THE COP SHOP

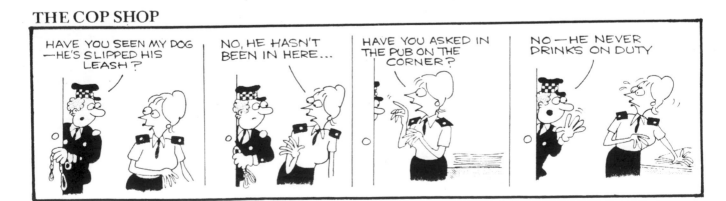

START BY DEVELOPING A CHARACTER...

YOU MUST BE ABLE TO DRAW YOUR CHARACTER FROM EVERY ANGLE AND STILL MAKE IT LOOK THE SAME— THEN YOU NEED A NAME OR TITLE...

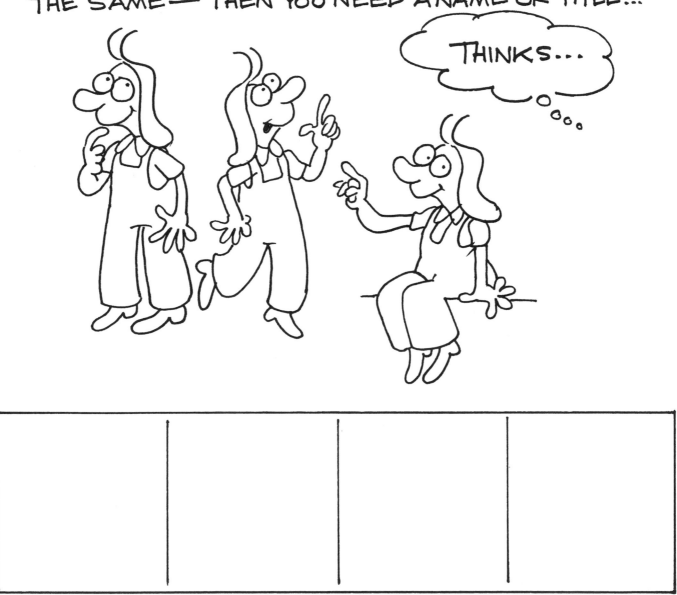

IF YOU ARE GOING TO DO A FOUR PANEL STRIP— DRAW A FRAME: 375mm X 114mm OR (14¾" X 4½")

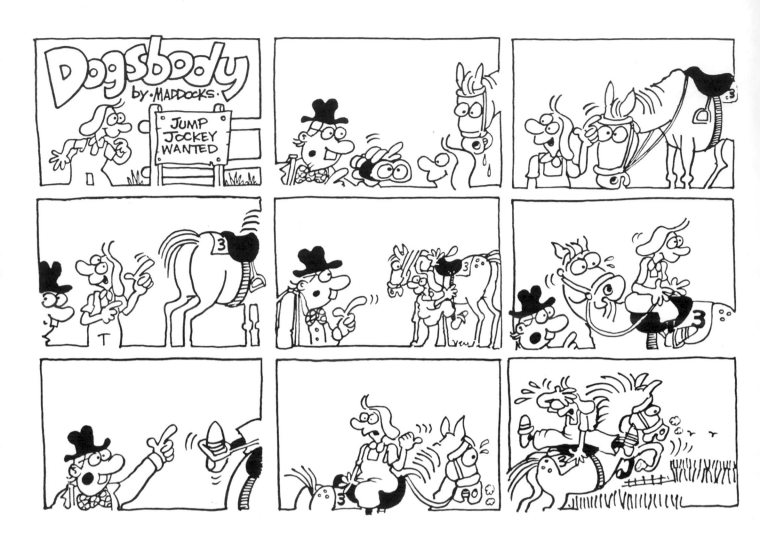

OR YOU COULD TRY A THREE PANEL STRIP (AS ABOVE)
THIS IS THE KIND OF STRIP USED IN WEEKLY
PAPERS OR MAGAZINES (IN COLOUR)

HAVING WORKED OUT YOUR GAG IN SCRIPT FORM
FOR DIALOGUE — YOU DRAW THE VISUAL ACTION.
I LIKE TO BLEND THE DRAWING INTO THE BORDER
LINES AS PART OF THE DESIGN OF THE STRIP.
KEEP THE DRAWING SIMPLE AND OPEN SO THAT
THE ACTION IS EASY TO FOLLOW...

THEN ADD THE DIALOGUE IN SPEECH BALLOONS—
DON'T CLOG UP THE PANELS WITH TOO MUCH DIALOGUE,
KEEP IT DOWN SO THAT IT IS AS BRIEF AS
POSSIBLE — BUT OF COURSE IT MUST CARRY
THE GAG TO ITS CLIMAX...

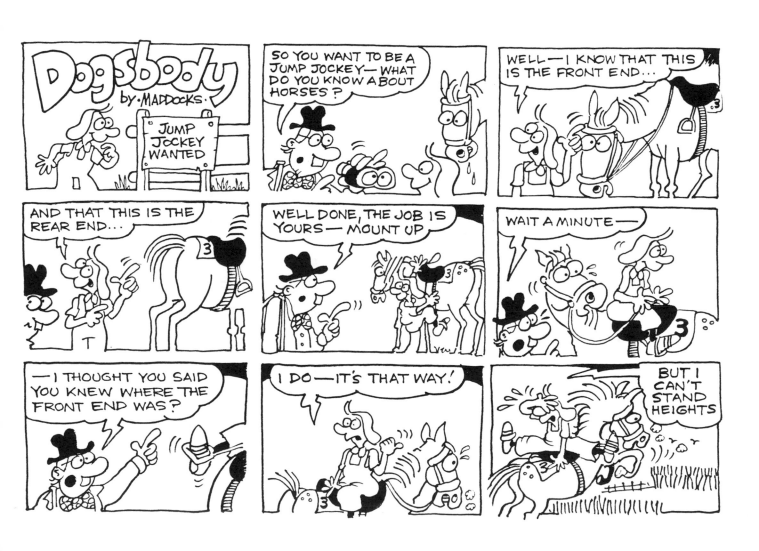

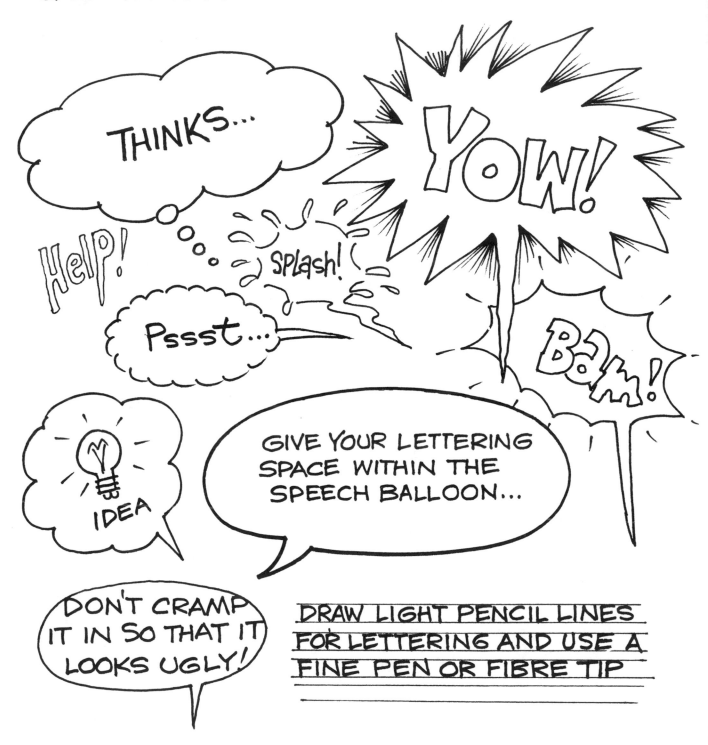

1	2	3	4	1

THIS IS A USEFUL TIP FROM A LAYOUT POINT
OF VIEW—GIVE AN EDITOR A CHANCE TO
MOVE YOUR STRIP AROUND THE PAGE
BY KEEPING TO AN EXACT FORMAT—
OBLONG, SQUARE OR DOWN

2

1	2
3	4

THE PAGE ↪

3

4

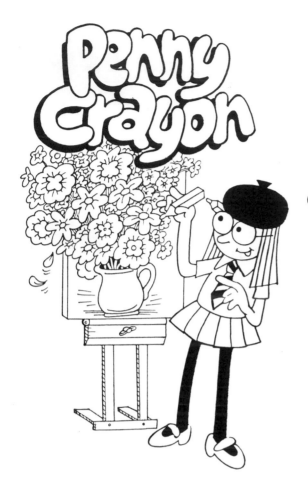

DRAWING FOR COMICS

I ENJOY THIS KIND OF WORK AND FIND IT QUITE RELAXING. PENNY CRAYON IS MY OWN CHARACTER DESIGNED FOR AN ANIMATED CHILDRENS SERIES CURRENTLY RUNNING ON BBC TELEVISION...

SHE HAS THE VOICE OF SU POLLARD SO I KNOW EXACTLY HOW SHE REACTS TO A SITUATION.

ONCE I HAVE THE WRITTEN SCRIPT AND THE BLANK PANELS ON MY DRAWING BOARD I FIND I CAN SWITCH ON MY RADIO AND START WORK — ALTHOUGH THIS ARTWORK IS DRAWN FOR COLOUR, YOU CAN SEE THAT PENNY, THE MAIN CHARACTER, DOMINATES THE SCENE WITH HER BLACK BERET AND BLACK STOCKINGS WHILE DENNIS, HER SIDE KICK IS LEFT OPEN JUST A BLACK OUTLINE — THE MOST IMPORTANT THING TO REMEMBER IS TO KEEP THE ACTION LIVELY AND NOT JUST HAVE TALKING HEADS...

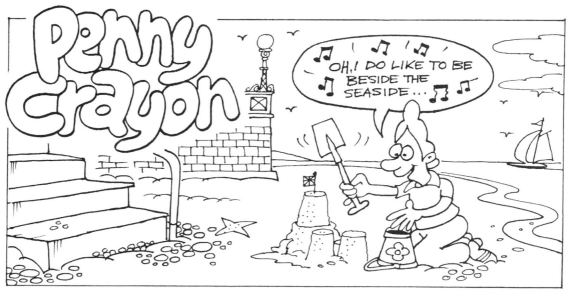

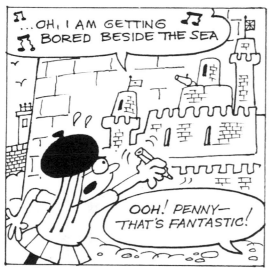

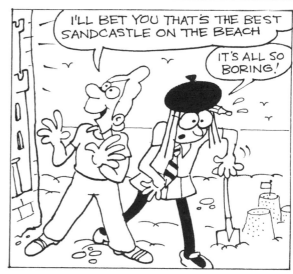

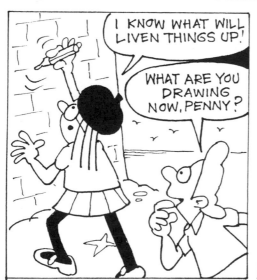

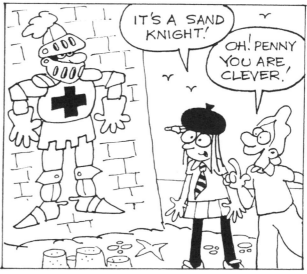

BACKGROUNDS...

CHURCH

ALWAYS KEEP YOUR BACKGROUND DETAIL SIMPLE—JUST ENOUGH TO ILLUSTRATE THE LOCATION

SCHOOL

DON'T LET IT OVERPOWER THE CARTOON— IT'S JUST THERE TO SET THE SCENE...

PARK

SIMPLICITY IS THE KEY— IF YOU OVERDO IT YOU'LL KILL THE CARTOON...

OFFICE

JUST KEEP IN MIND THE ITEMS THAT ILLUSTRATE THE SITUATION...

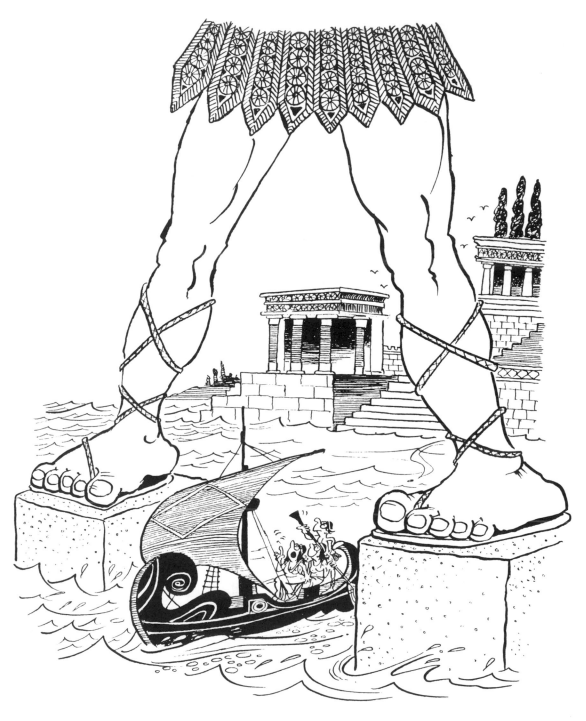

—"SO THAT'S WHY THEY CALL HIM COLOSSUS!"

HOWEVER——

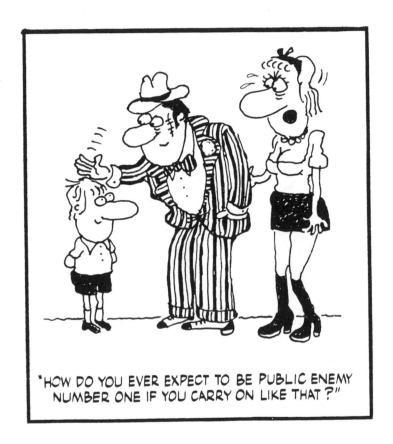

"HOW DO YOU EVER EXPECT TO BE PUBLIC ENEMY
NUMBER ONE IF YOU CARRY ON LIKE THAT ?"

THERE ARE SOME CARTOON SITUATIONS
THAT DON'T NEED BACKGROUNDS AT ALL.
ALL YOU NEED IS THE CHARACTERS AND
THE CAPTION...

...BUT ALWAYS REMEMBER THAT IF YOU DRAW IN A BACKGROUND IT MUST CONVEY THE CORRECT MESSAGE TO YOUR READER — THIS IS A JUNGLE, THIS IS AN OFFICE, THIS IS A FACTORY AND SO ON... DON'T DRAW IN A BACKGROUND THAT WILL CREATE PROBLEMS FOR A CARTOON — IF THERE IS NO REASON FOR THAT FAIRGROUND TO BE THERE, DON'T PUT IT IN — IT WILL ONLY CONFUSE...

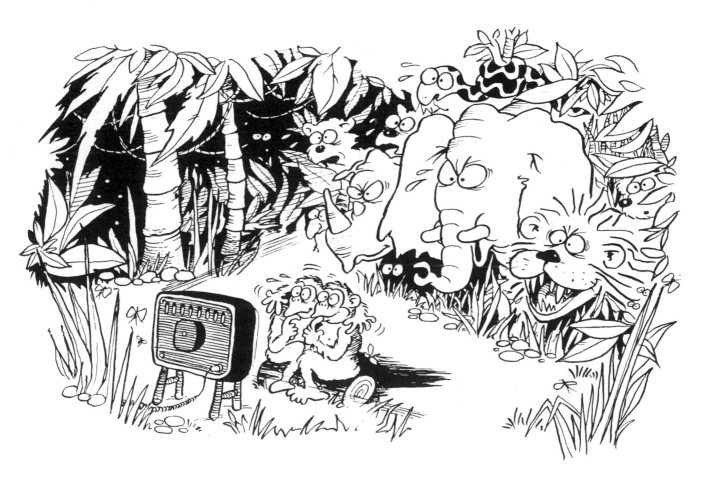

"...THESE WILD LIFE FILMS ARE FULL OF SEX AND VIOLENCE!"

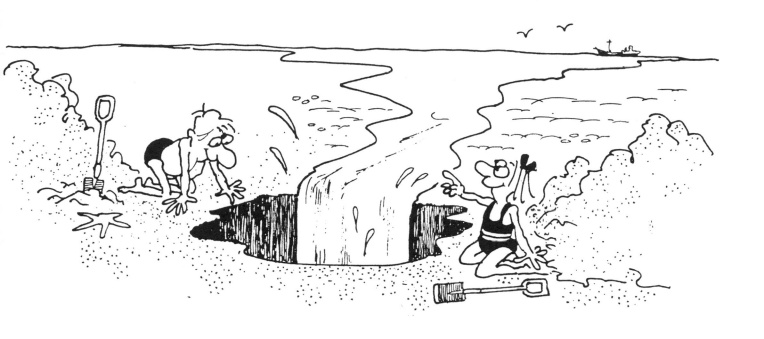

I HOPE THIS BOOK HAS ENCOURAGED YOU
TO TAKE A DIP INTO THE WORLD OF CARTOONING,
IT'S A TOUGH HARD ROAD AHEAD IF YOU WANT TO
MAKE A GO OF IT —— WORSE IF YOU WANT TO
EARN A LIVING, BUT IT HAS ITS COMPENSATIONS...

I HAVE BEEN DRAWING CARTOONS FOR OVER
THIRTY FIVE YEARS AND IT HAS KEPT ME SANE!